the art of
THE PORTRAIT

DISCARD

Revealing the Human Essence in Photography

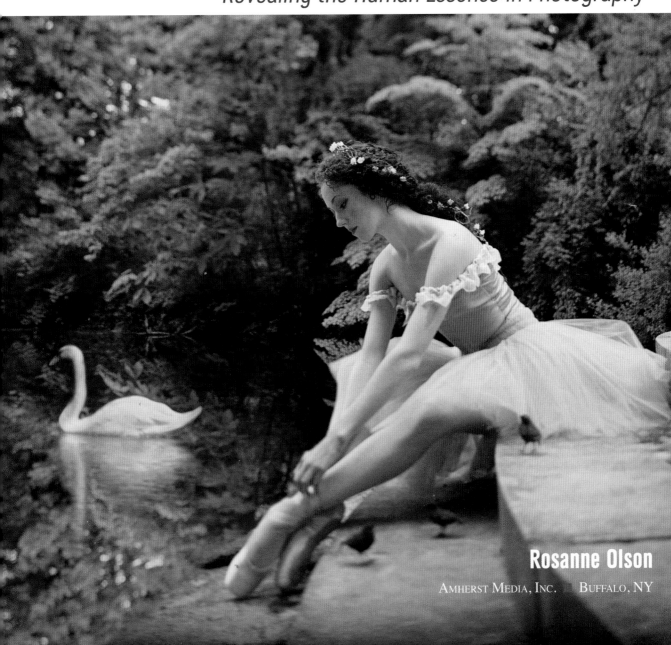

Rosanne Olson

AMHERST MEDIA, INC. BUFFALO, NY

Published by:

Amherst Media, Inc.

PO Box 538

Buffalo, NY 14213

www.AmherstMedia.com

Publisher: Craig Alesse

Senior Editor/Production Manager: Michelle Perkins

Editors: Barbara A. Lynch-Johnt, Beth Alesse

Acquisitions Editor: Harvey Goldstein

Associate Publisher: Kate Neaverth

Editorial Assistance from: Carey A. Miller, Sally Jarzab, John S. Loder

Business Manager: Adam Richards

Warehouse and Fulfillment Manager: Roger Singo

ISBN-13: 978-1-60895-973-0

Library of Congress Control Number: 2015944881

Printed in the United States of America

10 9 8 7 6 5 4 3 2 1

www.facebook.com/AmherstMediaInc

www.youtube.com/c/AmherstMedia

www.twitter.com/AmherstMedia

table of contents

my gratitude

In my career as a photographer, there are many who have helped along the way. There have been teachers, including Duncan McDonald, at the University of Oregon School of Journalism and Milton Halberstadt, at the University of Oregon Department of Art, both of whom offered wisdom that helped inspire and guide me.

There was the inimitable Brian Lanker, who opened the door for me as a professional photographer with my first job at *The Register Guard,* in Eugene, Oregon.

I am grateful to the many people who have given me opportunities to do creative work over the years of my career. And I thank my students, who have challenged me to take what I have learned and teach with clarity.

I thank my loyal assistant, Gail Smith, who has helped me stay organized for more than 14 years and who played a major role in preparing the images for this book.

And finally, and most of all, I thank my husband, Ted McMahon. His support for me and my career has been incredible. Our journey together continues to be a great adventure.

It is to him that I dedicate this book, with love.

Rosanne Olson

00 introduction

So the question is: what makes a portrait?

Truth be told, there is no quick answer to that question. Portraits come in many forms. They can be created in the studio or photographed on location. They can be lit with strobe lights, ambient light, hot lights, stage lights, or window light. They can be formal in composition or off-center and avant-garde. The subjects can be brides, babies, seniors, families, musicians, artists, authors, businesspeople, patients, politicians, even pets.

Photographing people has defined my career—the first five years as a newspaper photographer, then for twenty-five years as an editorial and commercial photographer. Now I am doing what I love most: simply making portraits.

Whether in newspaper photography, editorial, commercial photography, or private commissions, I have had the opportunity to photograph a rainbow of human beings, including nuns, musicians, opera singers, ballerinas, kids, babies, families, artists, and many discreetly nude women for my book, *This Is Who I Am—Our Beauty in All Shapes and Sizes.*

My first series of portraits began as my master's project in journalism at the University of Oregon where I worked for almost three years on a photo essay documenting the journeys of children with cancer. I had no experience with lighting, or with portraiture, for that matter. I owned only one camera and two lenses (a 24mm and an 85mm). Using only existing light, I explored the world of hospitalization, chemotherapy, surgery, family support, hope, and heartache.

I learned many things through that project—chief among them was that it doesn't take a lot of expensive equipment to create portraits. What it takes, at least for my approach to portraiture, is a compassionate heart and willingness to listen, observe, and search for the humanity within.

I tell my students that I am not sure I can teach exactly what I do. But I can, at least, tell them about my process. And then they can adapt it or find their own methods and make them their own. And though this book is one person's approach to portraiture, I trust it will be of use.

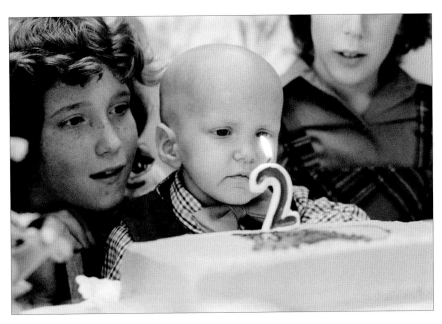

Darcy Welch, a participant in my graduate project about children with cancer, is surrounded by family at his second birthday.

01 who is in front of the camera?

In my first job as a newspaper photographer, I'd arrive at work in the morning and find two or three assignments in my mailbox. They would tell me what I was doing that day (or week). Often my assignments were oriented toward portraits for the paper's "Arts" section.

At first, I had a lot of anxiety and fear of failure with these portrait assignments. I worried about how to use the heavy, aging studio lights, which no one seemed to understand. This was before digital cameras. But even worse, we had no light meter and no Polaroid film to preview the lighting. If I wanted to see how my lighting looked, I had to shoot a roll of color transparency film, process it, analyze it, and make adjustments before the subject arrived.

Aside from the equipment, my bigger concern was making photographs that truly represented the person I was assigned to photograph.

I quickly got educated about light—through workshops and experimentation. I bought a light meter and a Polaroid camera so I could see what my lighting looked like. It helped immensely to be technically prepared for a photo shoot. But I still had to wrestle with the real issue at hand: how could I convey some truth about this multi-dimensional person on a two-dimensional piece of film?

I did my homework. I read up on the person. If possible, I would talk to them on the phone, which goes a long way toward making a connection. Even better, we would meet beforehand to talk so I could get a preview of whom I would be working with.

In many cases, the person I was about to photograph was probably just as nervous as I, for different reasons—wondering if I would do them justice with my camera. Many (most) people hope the photographer can help them look younger, healthier, taller, thinner, happier, or more brilliant than they are in real life.

My goal when I photograph is to try to discover the real person, the one who is often obscured by their nervousness when they come to the session. It is *connection* that helps the photographer get past the client's jitters to a place where both photographer and subject can be themselves.

who are we?

We are many things over a lifetime. But, we are many things at the same time, as well. It's the photographer's job to figure out how to approach the portrait by understanding what the client wants or needs.

And just as our subjects may be many things over a lifetime, so, too, can a portrait photographer—including journalist, advertising photographer, portrait studio photographer, wedding photographer, travel photographer, fine art photographer, and more.

Facing page: This series, called Woman Power, *was done for an exhibit at an art gallery to depict the many things a woman can be. For the series I photographed one woman dressed to represent the many possible faces and life experiences of one individual.*

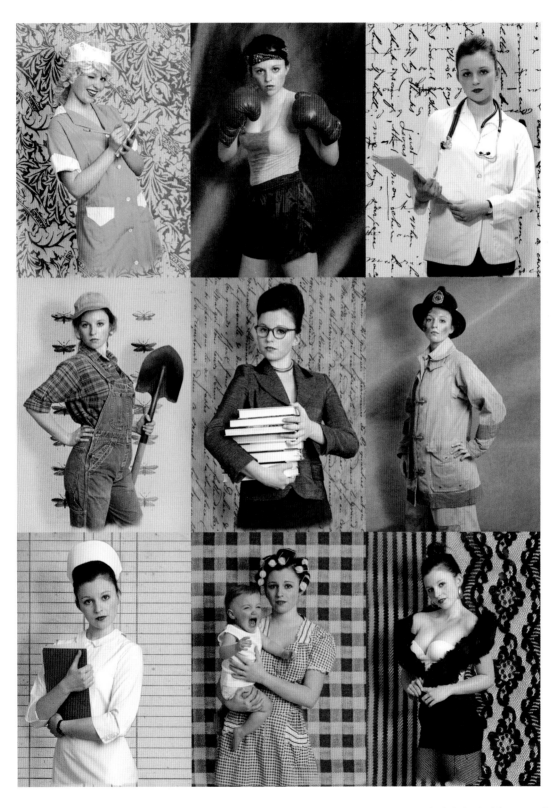

02 elements of a successful portrait

Even the simplest-looking portrait, if it is compelling, has many behind-the-scenes elements at work. First and foremost: the connection with the subject. Add to that the composition, depth of field, color (clothing, eyes, background, etc.), lighting, lens choice, environment, and body language. Let's consider some of these important elements now. Other topics, such as coaching the subject, body language, and lighting, will be covered in more detail later in the book.

We are drawn to look at an image for a variety of reasons. One thing that keeps us there (or brings us back for a second or third visit) is composition. There are names for different kinds of compositional patterns such as the very basic Rule of Thirds or the classic Golden Spiral. These are concepts of position or movement that help guide the eye as we explore a painting or a photograph. One can see these compositional guidelines at work in images or paintings that stand the test of time.

Angles and lines, color, and patterns can lead us into (or out of) an image. Once we have entered the photo, a subtle circular pattern helps keep the eye's interest for a prolonged visit.

The angles and lines of a photograph might consist of architectural elements such as a road or fence, the position of the body or limbs, a tilt of the head, lines created by dramatic light, patterns in nature, or designs on clothing.

Color is another element that helps guide us in. Cool and warm or complementary colors can work together to enhance the composition, creating mystery or harmony.

The tonal range is also an important element. The eye is drawn first to the lightest place in the image. If there is a specular highlight behind the subject, the viewer may be drawn away from the subject to the brightest spot. This will not necessarily kill a portrait, but being aware of how this works will inform your choices when you are photographing.

Facing page: A photograph of seven-year-old Jamie. The shallow depth of field draws attention to the focal point: her compelling eyes. The lines created by her arms and long hair create a circular pattern or spiral that leads us back to her eyes.

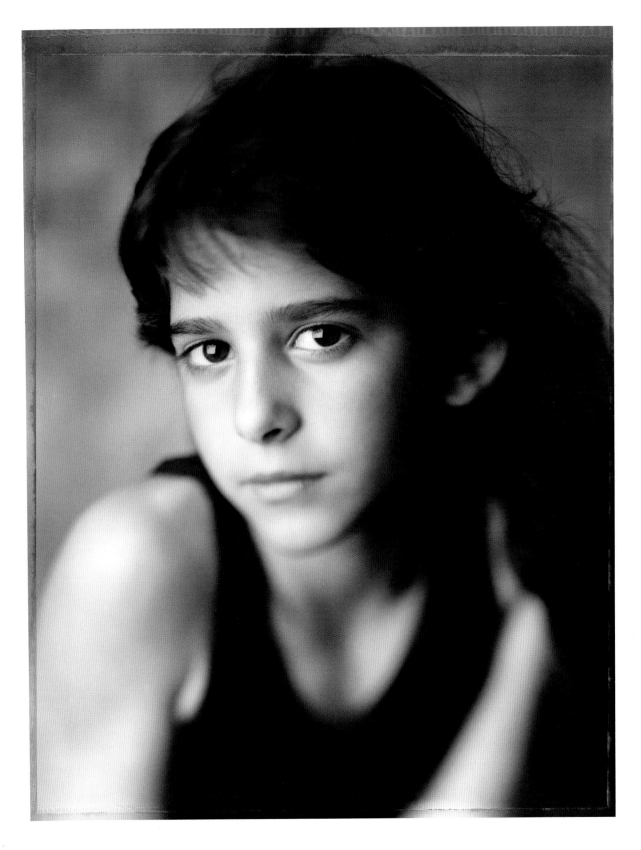

Contrast and tonal range are related. One can create a low key (dark) image in which the face or eyes are the lightest area and thus draw the viewer's gaze. Or one can create a high key (light) image that draws the viewer to the eyes—in this case perhaps the darkness of the iris, the lashes, the eyebrows—or even the lips. In each case, high or low key, the viewer's eye is drawn to the opposite tonal value: if the majority of the image is dark, our eyes will seek light, and vice versa. For more on lighting, see chapter 4.

Depth of field is another element to consider. The viewer is drawn to the sharpest part of a photograph. A shallow depth of field (such as that achieved when using an aperture of f/2) gives the photographer the ability to focus on the eyes of the subject. If you have a "fast" lens (one with a large aperture) the eyes can become the focal point while the rest of the face goes slightly soft as it falls out of focus. Basically, the photographer guides the viewer to the place of sharpest focus whether it's the eyes, fingers, a cigar, etc.

Shallow depth of field is more easily achieved with continuous light (either natural or artificial) than with studio strobes because for many strobe power packs, the intense amount of light output from the flash tends to require a smaller aperture, which means more depth

of field. This can certainly have a place in portraiture, especially when photographing a group. However, if you want a shallow depth of field when using strobes, it may require a bit of effort to reduce the light output (neutral density gels may help). Working with dedicated flash (a speedlight), on the other hand, makes it pretty simple to use a shallow depth of field or extensive depth of field with the turn of a dial on the flash or the camera.

Choice of lens will have a profound effect on the image. A wide-angle lens can incorporate a broader vista of background behind the subject for an environmental portrait. If the lens is very wide, for example 24mm, and the subject is close to the lens, the subject will be somewhat distorted, depending on how wide the lens and how close the photographer. If the lens is long, such as a telephoto, the background will tell less of a story and the focus will be mostly on the subject. Isolating the subject with a shallow depth of field is easier with a long lens.

Top left: The portrait shows contrast and line. In addition, it was shot from a low angle, as was the one next to it. Top right: The strong diagonals of the flag and body engage the viewer in the image's subtle circular pattern, with the rocks helping to keep the eye in the photo. Bottom: The lines of the fence and arm lead to the model's face, in sharp focus.

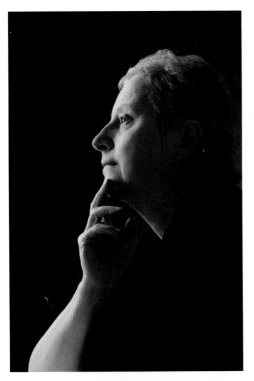

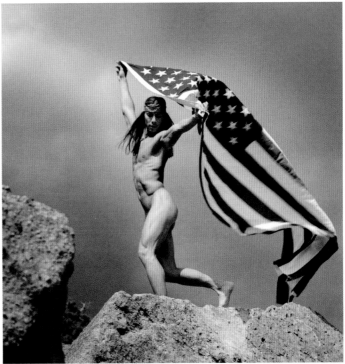

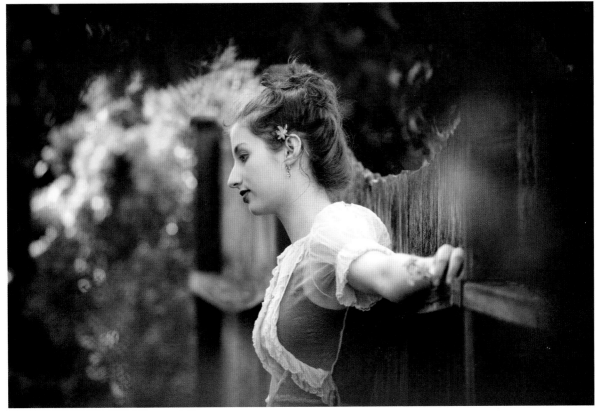

Camera height can greatly affect the portrait. Positioning the lens slightly above someone has certain advantages. For example, if a subject has a heavy chin, moving slightly above will deemphasize the chin and direct the viewer more to the eyes. The opposite—a low camera angle—will make the person look more powerful or heroic. It also gives a view up the nostrils, so it is important to be aware. Everything is a choice to be made, and it all makes a difference.

If telling a story about a person with multiple images, one can incorporate a variety of wide environmental and close images, as well as vertical and horizontal framing.

Awareness of all of these elements, like learning a language, is achieved through study and practice. It is useful to analyze every photo, painting, or film one is drawn to (or not drawn to). What is compelling about an image? What are the design elements that draw the viewer and keep asking for or demanding our attention?

Even after many years as a photographer, I love the process of dissecting the lighting and compositional elements of all kinds of imagery when I go to museums and art openings. For an image (photograph, film, painting) to stand the test of time, it has to engage the viewer on multiple levels. What are those elements? Why are some so compelling and others less so? What makes me want to go back again and again?

To put all of this to work, it is helpful to set up practice shoots. I recommend sketching out ideas ahead of time. That way it is easier to remember everything in the heat of the photography session. It also helps to organize props, clothing, and vantage points. It is not necessary that every idea be photographed, but at least there is a guide for how to organize and approach the session.

Every less-than-successful photograph will become a teacher.

And of course, not every photography session will lead to success. What *is* important to remember is that every attempt will add to one's depth and confidence as a photographer and help to develop personal style. Every less-than-successful photograph will become a teacher.

Facing page: Alex Small, at 103, lives in an assisted care facility in Seattle. The images tell a brief story, simply told through a shallow depth of field (top left), a wide shot (bottom), and a detail of a framed image of Alex with his wife (top right).

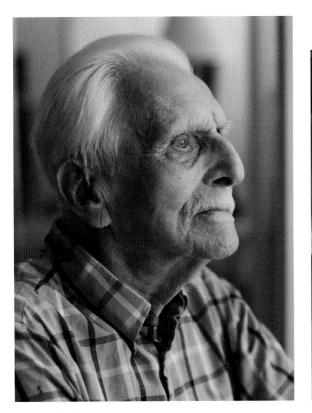

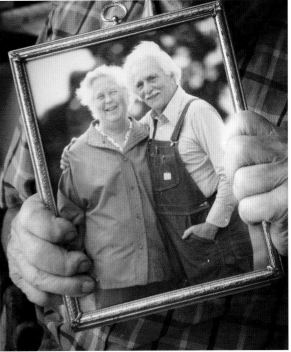

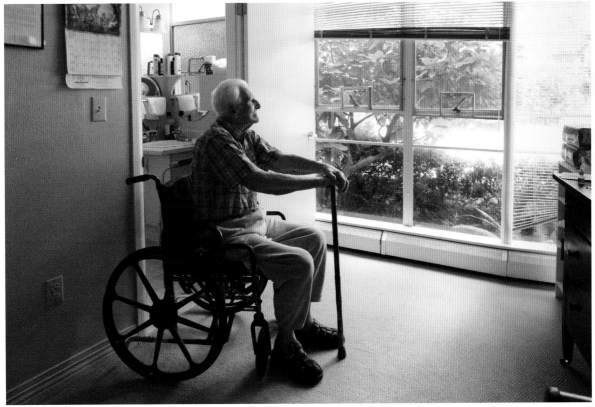

03 find a starting point

When someone contacts me for a portrait, the first thing I request is that we talk on the phone. I ask questions such as:

Did someone refer you to me?

Have you seen my website?

Can you tell me a little about yourself (and/or your family)?

What would you like to accomplish?

What do you want as a final product?

And . . . What can I do for you?

When a client commits to a session, I invite them to sit down for cup of tea or coffee and conversation in my studio, prior to the session. I feel it is important to the success of the photography to have the trust of my subjects. I believe that the preliminary work—the "getting to know you"—is almost as important as the photo session. Why? Because I want the photograph to be about the subject as much as possible, and the more I get to know them, the better able I am to connect with them deeply. I even try to sit down with clients whom I have photographed over many years. It is good to catch up, learn about what's going on, and discover something new. And then the photos follow.

I have a story I like to tell about an orchestra conductor I photographed for a magazine. The art director called me to say that the conductor could be impatient and he would likely give me only a few minutes of his time.

The maestro arrived at my door carrying his tuxedo, looking somewhat tense but not nearly as fearsome as I had been warned about. When he told me he had only 45 minutes, I invited him to sit down for a cup of tea, which he did. When I asked him about his life, he told me about how he got into music, and then he talked about his family. That made him smile. We talked for 30 minutes. This was precious time I could have been photographing him. Instead, I was watching him ease into his natural self.

A few minutes of conversation can make a big difference.

Then we went into the studio. In the remaining 15 minutes, I photographed him with an ease that comes with familiarity and quickly achieved a photograph we both liked. Could I have gotten the same kind of photograph if we

had *not* spent the time talking? I doubt it. So this has become part of my modus operandi (and part of the joy of portraiture). I try to get to know my subjects a little before I bring out the camera.

What makes my subject happy? What are their passions? Who are their kids? What are their hobbies? Where do they like to travel? I learn what makes them laugh or cry. I want to know what they look like when they act naturally because when we go to the studio they might start to worry and I can bring them back to those funny or sad stories. It is not an interview, just an easy conversation that allows me to witness the person in a relative state of relaxation.

Something wonderful happens when we feel listened to.

There is something wonderful that happens when we feel listened to. It is what we hope for when we go to a doctor or therapist: to be seen for who we are. So that's what I offer my clients: my complete, non-judging presence with a goal of finding out what is beautiful in each person. And then, I try to coax that beautiful self into a photograph that may live on for generations.

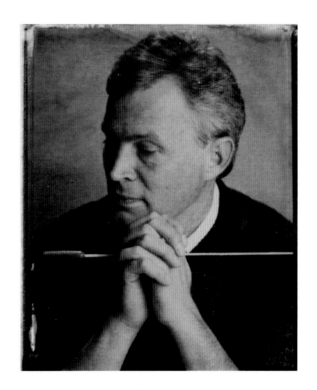

04 a brief look at light and fill

People who are new to the topic of light may not be aware of all the choices and tools that are available to them. Good lighting is either created by the photographer or found in nature by the photographer and put to use. Sometimes we use a combination of artificial and natural light. This takes study and practice. If you are interested in learning about light, take a look at my book *ABCs of Beautiful Light,* which is a basic course in lighting.

Here are a few things about light to consider when photographing:

1. *The position of the light relative to the subject.* If you imagine an overhead view of your photo setup, with the subject facing the camera, a light source placed directly in front of the subject creates a light that flattens the features. If you move the light left or right around the subject in an imaginary circle, you will get an increasing amount of drama as the light moves toward the side and back of the subject. The patterns of light and shadow have names, such as loop light, Rembrandt light, and split light.

2. *The position of the subject relative to the light.* (This may sound the same as #1, but it's not. Read on.) If you have a light source illuminating the subject from the side, a gentle turn of the head toward the light will fill the face with light. This is called short light. Turning the head away from the source lights the face from the nose to the ear. This is called broad light. A turn of the head or body while the light remains stationary will produce differing light patterns and very different results.

3. *The use of fill.* Bringing light into the shadow side of the face can completely change the character of a photograph. I recommend a 30x40-inch piece of white foam core (white board) attached to a light stand with an A-clamp as a good and able assistant. The fill card can bounce light from the original source, such as a window, with great efficiency. The closer it is to the subject, the more fill there will be. The farther away, the less fill and the more dramatic the light will be. Fill cards can be used indoors and out. If working outdoors, it is a good idea to add a ballast to your light stand (e.g., a sand bag or camera bag) so it doesn't go flying in the wind.

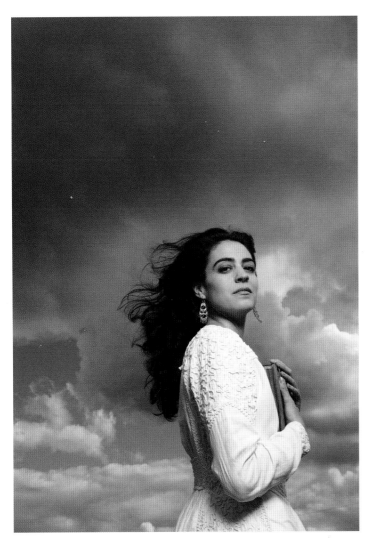

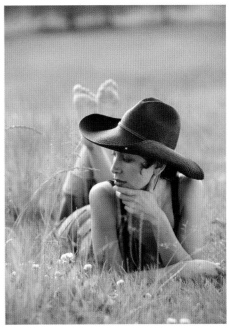

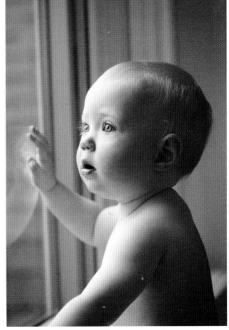

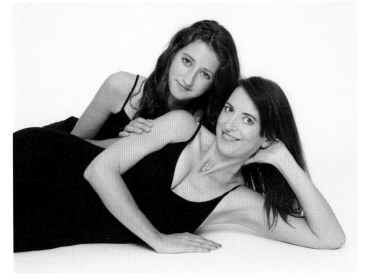

Clockwise from above left: Strobe and daylight combined for dramatic skies. Natural, soft backlight with fill card. Window light only. Studio strobe.

4. *The height of the light.* Photographing outdoors at noon on a sunny day may result in some unflattering shadows on the face. When people sit around a campfire, the fire light that rises up to illuminate their faces creates a different kind of light, just the kind to tell a scary story. Awareness of the height of light (high, low, and in-between), plus the position of the light around the subject will help tell a story. If the light is high and overhead (noon), it can be made better, for example, by asking the model to lift her head. Whether working with ambient light or strobes, the height of the light facilitates the story being told.

5. *The quality of light.* Quality refers to how hard or soft the light is. For example, a cloudy day or a north window will produce a soft light, while a sunny day may lend a more direct light with sharp shadow edges. This is true with studio lights, as well. Thus, manufacturers of photo gear make modifiers, which are placed in front of lights to help manage the hardness or softness of the light.

Lighting for portraiture can come in the form of daylight or artificial continuous light (LEDs, tungsten lights, or daylight-balanced fluorescent sources); or strobes/dedicated flash). Each light source has its own advantages.

For example, outdoor shoots must be scheduled early or late in the day for the best light. And what about the weather? If the weather is not cooperative, having a backup plan is imperative.

Artificial light is nice because it can be moved around, though the lights are sometimes cumbersome and usually require an electrical outlet or generator. There are modifiers available for various continuous artificial light sources; however, some of these lights produce heat, so modifiers for those units may be limited. Continuous lights can be used with still and video cameras.

Strobes are versatile but are only useful for still photography. They can be used in conjunction with daylight as fill or as a main source. Some brands are battery-operated, and thus can be used outdoors or in locations where there is no electricity. There are also many modifiers made for strobes, such as softboxes, beauty dishes, grids, umbrellas, etc., that allow the photographer to choose how hard or soft the light will be.

The more you know about lighting, the more you will be able to adapt to each situation and create the look you want.

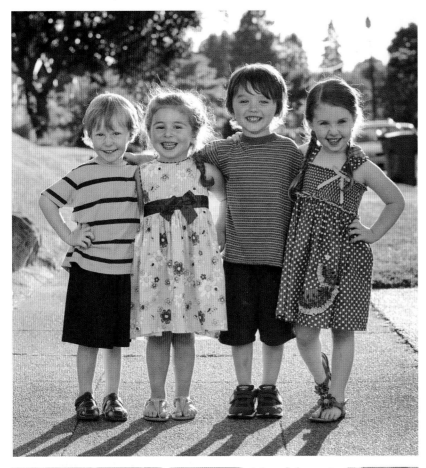

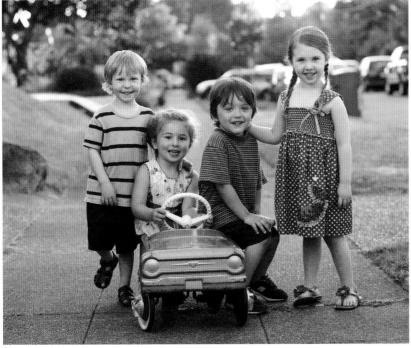

These images are outtakes from a photo shoot I did for Avanti cards. The top photograph was taken just prior to the actual shoot. The warm afternoon sunlight was reflected back into the kids' faces with fill cards. The bottom photograph was shot at the end of the session. The sun had gone down. The image has a cooler color. Also, the light is flatter, as there was not much sunlight left to reflect back into their faces. Still, the light lends the sweet afterglow effect we expect on a summer evening.

05 location or studio?

Photographers don't always have a choice about whether or not to use a studio. Studios certainly can come in handy when the weather is bad. Or during short, dark winter days. By far, the main factors in deciding what to do with a photo shoot are based on the client's needs and the photographer's lighting skills.

Photographers who use only natural light are limited to what nature provides, including beautiful outdoor daylight or window light, and by how much light there is at the time of year. The truth is, though, that sometimes nature's light is not so beautiful. So it helps to be prepared for alternatives.

For those who are skillful at using artificial light (strobes, dedicated flash, and continuous light sources), the choices are not weather dependent and thus there is more potential. It all depends on what you are comfortable with, what your style is, and your skill with using lights.

My advice is to always keep it simple and make sure you are comfortable with what you are doing. Don't use a paid photo session to test your new lights. That's what test shoots are for.

There are many times that I will photograph a portrait both in the studio and outdoors. I like the intimacy of the studio for working closely. It allows time for the subject to relax and for us to get to know each other. So I will usually do the studio work first. Moving outdoors after working in the studio allows us to ease into a more relaxed outdoor session.

Another option is to photograph inside a client's home. The use of natural light may be limited inside homes, so it's a good idea to scout the location ahead of time. Windows that face north (in the northern hemisphere) will likely provide beautiful indirect light throughout the daylight hours. If the client has only windows that receive *direct* light, plan to photograph at a time of day when the sun has gone over the house and the light is indirect.

Facing page: I first photographed this family in the studio, then I took them outside. For the outdoor image, I photographed them from a low angle to emphasize the blue sky. I lit them with a strobe, which allowed me to select a shutter speed that made the sky a darker blue. The wind in the subjects' hair gives a nice feeling of spontaneity.

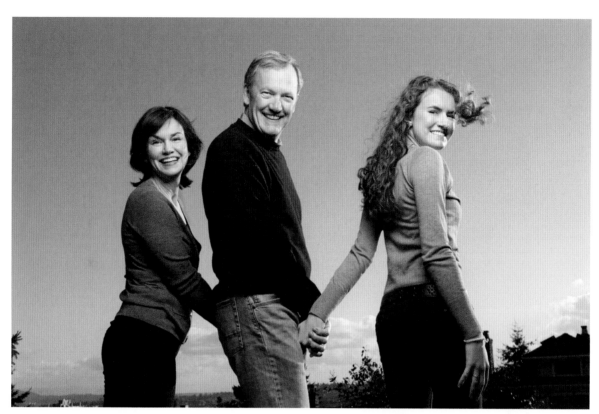

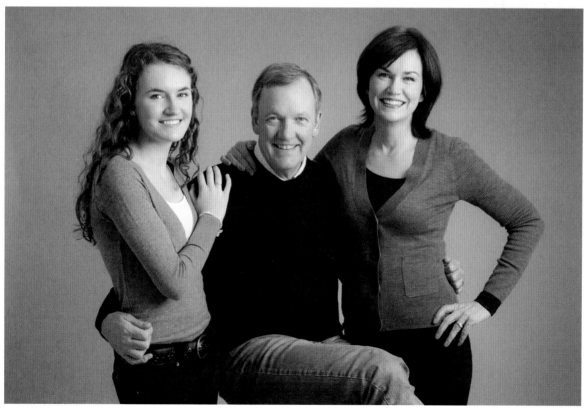

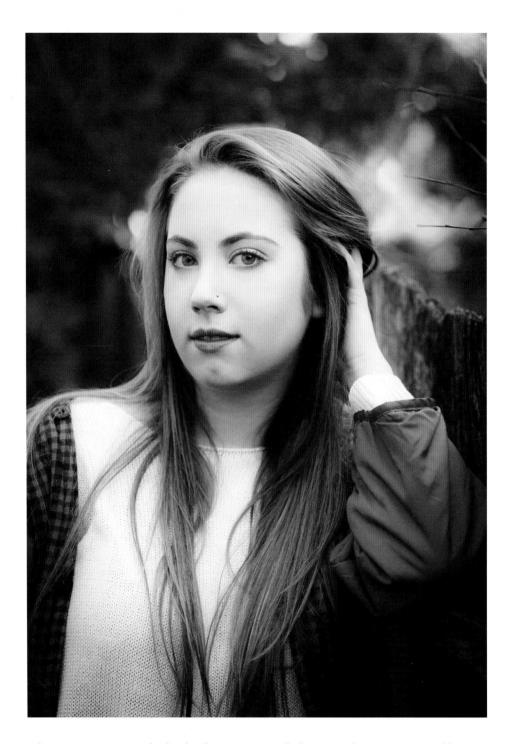

This young woman, a high school senior, wanted photos outdoors, as many of her friends had done.

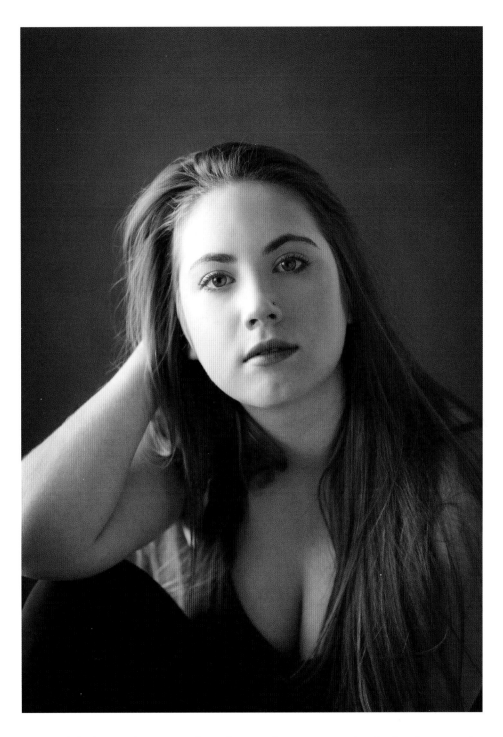

Meanwhile, her mother was wishing for a studio-type image that had a classic quality to it. We did both, and everyone was happy.

06 clothing, hair, makeup & retouching

Considering that a photograph can live a long life, even into future generations (recall the photos of our parents or grandparents), all decisions about clothing, hair, and makeup will accompany that photo forever.

clothing

Clothing choices are important. If it's a portrait of a professional, the image will tell a story about the individual. If the clothes are wrinkled, fit improperly, or are not flattering, it says something about who they are. If the clothing is neat and well-fitted, it says something else. Thus it is important to coach the client on what to wear. This is true no matter who the subject is, from high school seniors to executives.

When I first talk to my clients, I try to get a sense of their personal style and what they like to wear. Then I give them my suggestions, which include no large logos and no bold patterns. White is not the best (because it draws attention to itself), though it can work, especially if it is that person's trademark look. I want the portrait to be about the person. The clothes serve an important supporting role.

I also suggest that my clients bring clothes clean and on hangers. No stuffing them into bags (this happens a lot). If the clothing comes wrinkled, we will need to take precious time out of the photo session to iron or steam them. And if unwanted wrinkles appear in the garments, retouching takes time and costs money. So it's best to deal with all that beforehand. There are exceptions, of course. For example, someone whose personal style is actually the rumpled, just-out-of-bed look that some famous musician or writer may cultivate. I use my discretion.

I send my clients a PDF that outlines the above information. I also discuss clothes, hair, and makeup on the phone. Also, I always ask people to bring at least three things to choose from because once we start working, some clothing works better than others.

Occasionally I get a client who has no sense of what to wear and no real personal style. They need help. For those people (male or female), I recommend a shopping trip with a clothing stylist, someone accustomed to working with photography.

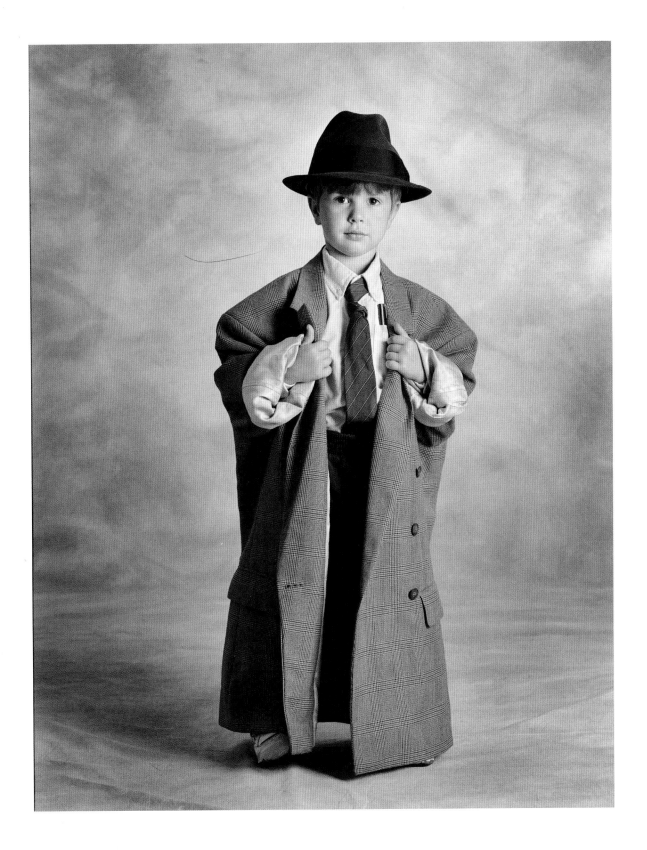

When the time comes for the photo shoot, I may have the client(s) try on a few different tops so I can see what looks best on-camera. We start with the clothing that seems best. Once we have made the clothing decisions, then the photo can be all about conveying personality. If there is time, we may try another outfit. I pay close attention to how clothing moves, bunches up, pulls in the wrong places, shows lint, etc. It is much better to fix those things during the shoot than in Photoshop.

For families, I am much more casual. I am not a photographer who asks people to come with matching clothing unless they prefer it. I make my basic suggestions (no logos, no bold patterns, etc.) and then ask them to bring a few choices, some in mid-tone colors, on hangers if possible. I actually love it when kids get to be their own creatively-dressed selves, showing their uniqueness and tastes, whether jeans or a tutu. But if a family wants to have a more planned look (all black, all jeans, etc.), I am fine with whatever makes them happy.

hair and makeup

The kind of work I do tends to be pretty natural-looking, though that doesn't mean I don't recommend makeup (for older teens and adults). A little makeup can make a big difference, though it must be applied with skill. Cameras have a very detailed eye when it comes

to skin tones and imperfections. The camera will tend to emphasize blemishes and redness. Skin that is glossy from facial oil can be very unappealing.

A little makeup can make a big difference, though it must be applied with skill.

If working on a commercial job, I hire a makeup artist and hairstylist (sometimes the same person) to do makeup/grooming on both men and women. However, if working on portraits of individuals, I know that not everyone can afford to hire a stylist. So I have a few workarounds:

I suggest that women who normally wear makeup do their own makeup with a light touch. No glittery eye shadows or glittery lipstick, as they can be tricky with digital cameras. I ask them to bring their own makeup so we can add to it if need be. I am not a makeup artist, but I can guide my client to a good result. Another inexpensive option is to have makeup done at a department store makeup counter such as Bobbi Brown or Mac. I ask my clients to tell the makeup artist that it is for a photo shoot (no glitter) and suggest that they purchase some products after the session for the service they received. Or I offer to hire a professional makeup artist, whom they pay at the session.

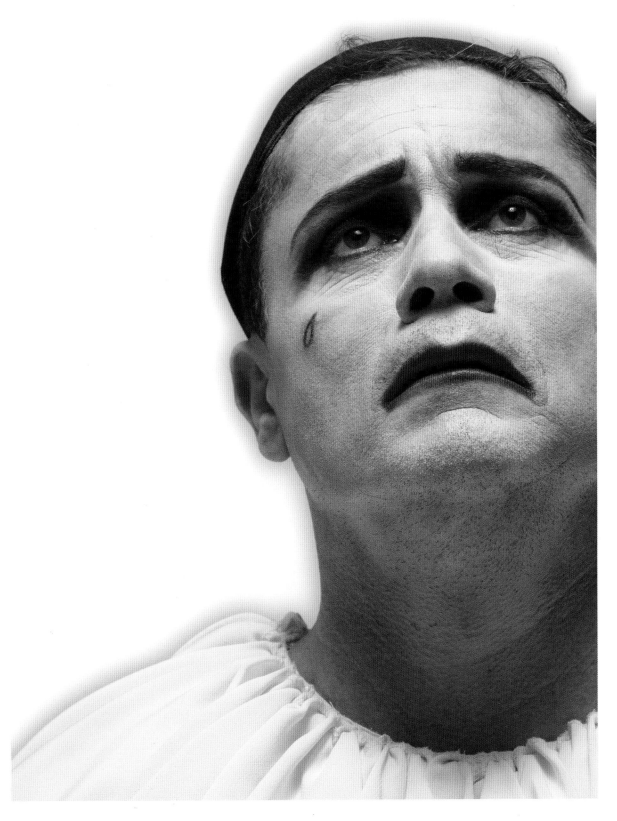

Even if one uses a professional makeup artist or hairstylist, communication is essential. What does the client normally look like? Natural skin? Eyeliner? Color of lipstick? It is easier to add more makeup than to take it away. The whole process is one of communication. If communication doesn't happen, the client won't like any of the photos.

For men, I purchase clay-coated skin-oil blotting papers, available at makeup departments or drug stores. This product helps to remove facial oils. I also keep several tones of face powder on hand. I ask men to shave just before coming in for the shoot. If they are coming from work, I ask that they bring a shaving kit, just in case they need to freshen up. Some stylists carry extra razors and shaving cream for that purpose.

In the end, with a little makeup and a little skin retouching, the results can be both beautiful and realistic.

Hair is less of a problem. People tend to arrive with their hair looking like they want it to look. If clients go to a hair salon prior to the session, they need to make sure that the person they work with knows them and their hair well so they don't end up hating the photos because the hair is not right. Also, it is *not* a good idea to get a haircut just before the session. If the client needs a haircut, then wait a few weeks for the photo session until it has grown out a bit.

hands and nails

Often, hands end up being in the photo. I highly recommend a manicure prior to the shoot. For women, a clear polish or no polish. For men, just a manicure. For some of the families I photograph, everyone ends up barefoot on the floor, so I suggest making both the hands and feet look good prior to the session. That way we can be spontaneous about what direction the photos take.

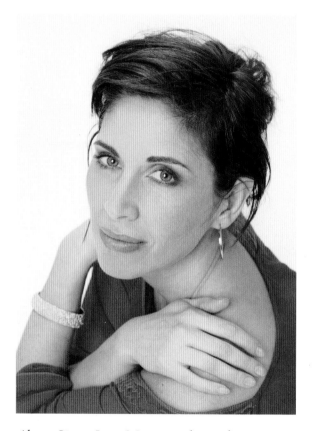

Above: Singer Jessie Marquez after makeup. Facing page, top: Jessie Marquez applying her own mascara. Facing page, bottom: Two well-cared-for hands for a wedding portrait.

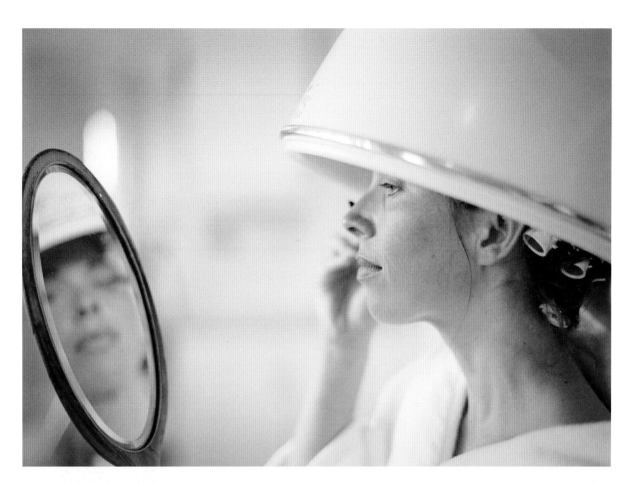

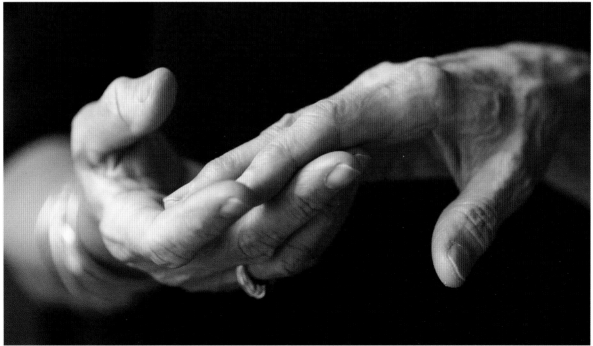

Before photography there was (and still is) painting. Court painters who created beautiful paintings of royalty usually depicted their subjects in a flattering way—a version of what we do these days with Photoshop. Retouching is an art that is done by most photographers and, in fact, was done by photographic retouching specialists long before Photoshop came along.

The camaera has a way of seeing skin that tends to be harsher than our actual eyes and brains perceive reality. Skin tones appear red or blotchy, teeth are yellow, and eyes have red blood vessels that become more apparent on the screen. Lighting can make a big difference, but then, to clean everything up after the photo session, we have retouching.

Retouching can be done non-destructively in Lightroom and in Layers in Photoshop (so it can be undone or toned down). There are many retouching software programs available as well as numerous classes and videos online (such as Creative Live and on YouTube).

retouching

The amount of retouching depends on the photographer's style and on the subject. For example, for business portraits, you would not likely want the people to look artificial (why would you ever?). Children rarely need much more than a few touchups of dings or scratches.

For teens, especially those with acne or other skin difficulties, I take the long view and clean up the skin so it looks good, but real—as it will likely look in a year or two, anyway.

For fashion, retouching can get sort of crazy. Our culture has created an impossibly "perfect" cover girl. In advertising and in magazine editorials, people are made to look forever young, even if they are 80.

For my female clients, we retouch enough to help them feel beautiful—like a slight digital facelift, but not artificial-looking. That little boost helps raise spirits and makes the clients feel good about themselves. Older people, especially women, are used to seeing their faces in the mirror softened by not wearing glasses to look at themselves, or by still feeling like a version of their younger selves. When confronted with the harsh reality of a digital file that has not been retouched, the response can be agonizing.

I refuse to make people look like aliens, however, and I really find that overly retouched look to be out of the realm of what I am comfortable with. One thing that photographers need to know is that the quality of light makes a big difference. To help clients look younger, with fewer lines, I use a large light source positioned at roughly a 45-degree to front position and at a height of about 10:30 or 11:00 (for more

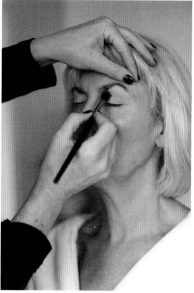
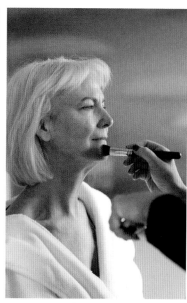

information on this, see my book *ABCs of Beautiful Light*).

Much beauty portraiture is done with this kind of lighting. It creates an almost shadowless look rather than enhancing shadows in the lines, crow's feet, and other signs of aging. In other words, it instantly makes people look younger and more luminous. Right away the photographer and subject are at a better starting point for retouching, needing less to make the portrait look good.

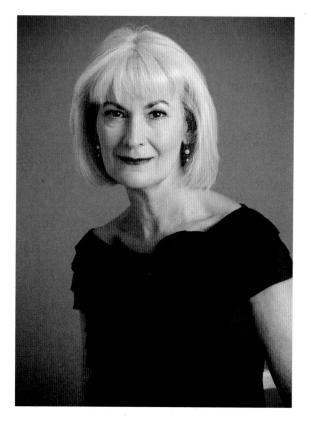

Retouching can be very time-consuming. We estimate that we will spend 20–30 minutes for an image (this is included in the fee), but there are many times it goes beyond that. In that case, we charge an hourly fee in 15-minute increments. I educate my clients about what their options and costs will be so they can decide.

Above: A sequence of makeup steps and the final version. The model's skin was very nice to begin with, so after makeup we did only light retouching.

07 coaching the subject

It is a fascinating and educational experience to be photographed by another photographer—to appreciate what it feels like to be on the other side of the camera. In my classes, I often ask my students to photograph each other so they can be more empathetic when working with their own subjects.

People differ in how relaxed they are under the unblinking eye of the lens and in how easily they are able to be themselves. It is the photographer's job to guide the subject to a state where they feel free to be natural. This varies with each individual. Some people freeze and become anything but themselves, and some find it easy, if not exciting, to be photographed.

As I discussed earlier, my usual approach to a portrait is to spend some time talking to the individual before we begin the photography. Over a cup of tea or coffee, I like to have a casual conversation about their work, their kids, their interests, etc. This time spent together prior to the session allows me to observe how they respond when they are discussing something that makes them happy—or sad—without a camera creating a barrier.

From that point, during the session, I may refer to something in our conversation to get them to return to a certain expressive place. For example, if they talked about something funny that happened at a family picnic, I can try to bring them back to that place and to that feeling.

Bring the subject back to an idea or feeling rather than asking for a smile.

I actually use suggestions like this a lot when I work. Rather than trying to create something artificial ("smile for the camera") I will ask my subjects, for example, to think about something in particular that makes them happy or contemplative. I will give them a minute to reflect and then work on capturing a look that is true to that individual. Another subtle technique I use, if want a smile from someone, is to smile at them from behind the camera. It's amazing

Facing page: I had a great conversation with this young man about his life, struggles, and ideas before beginning the portraits. I asked him to move through his thoughts, pausing when it seemed right.

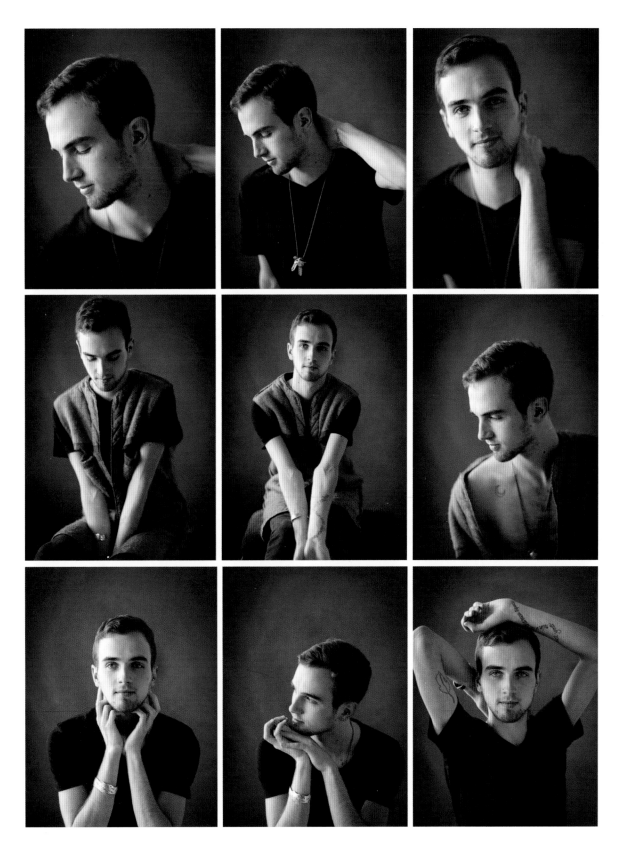

how well this modeling behavior works to get a natural expression.

What to do with appendages is another question. That, again, is where the initial observation comes in. In watching people talk, I can see how they gesture, use hands, cross legs, etc., so I can refer to that during the shoot. Another thing I often do is put down the camera and leave the studio for a moment—perhaps to get water for us. When I return, my subject has often settled into a posture that is truly his or her own.

Of course, not everyone is conscious of how they use their hands, arms, fingers, and legs. If hands end up in a photo, I try to always be aware of the composition. Does the arm/hand lead the viewer's eye to the face? Does the hand press too hard against the face and cause distortion? Be aware of the back of the hand facing the camera—it can look like a fist. Rather, turn the hand sideways so the curve of the fingers face the camera. These small suggestions can improve the composition and attractiveness of an image.

Taking it further, I might make a suggestion based on body language I have already observed. If my direction doesn't make sense, I may change places with them for a moment to have them observe me. Then I tell them to experiment and make it their own. In all cases,

I try to avoid frustrating my client with too many directions.

Something I do that not every photographer does is share some of the images on the back of the camera. I wait until I have several options that I truly like before I share. Once we have reviewed some of the images, I ask how they feel about what we have achieved before moving into a new direction. It is important to me (especially when the photo is being made for or about that person) that they like what we are doing. They may see something that I am missing about their smile, hair, or expression that we can improve upon. The photographer is the interpreter but can only interpret what is given. It is a deep communication that leads to discovery.

In my world, a portrait is a collaborative effort. It is not about me, as the photographer, though the photographs are filtered through my experience, vision, and style. If I can create a photograph that makes me happy, that is great. If the photo makes the client happy and/or feel good about him or herself, then I have done my job.

Facing page: For these images, I put on some music and gave the mother and daughter a chance to warm up and have fun. After many frames, they plunked down on the studio floor into each other's arms. This is a pose that I would not have created without seeing the evolution.

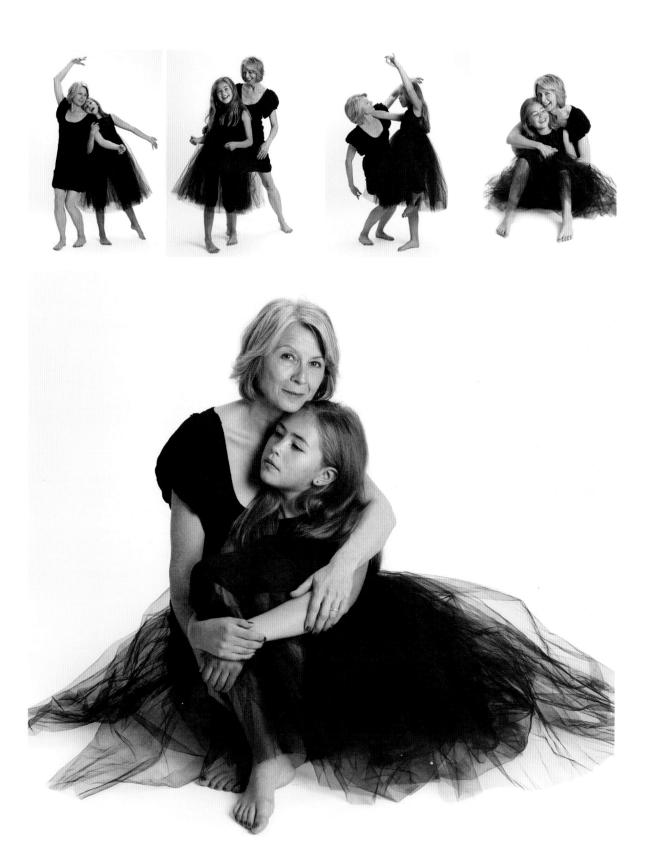

08 children

I love to photograph children. They are generally unfiltered and honest, with little or no baggage about how they look or who they are. Children love to have fun and love to be entertained. If you can get their attention and make the photo session enjoyable, you will get great photos. But once they are done (hungry, tired, bored), then there is hardly anything you can do to bring them back, especially if they are really young.

My approach to kids in the studio is to have the lights and background dialed in before they arrive. I usually use broad lighting—a softbox or octabank (or umbrella, if that's the broadest light modifier available) or window light—so there is plenty of room for the child to move around.

I have photographed so many children over the years: for magazines, for advertising, and for families. Every situation presents its own unique challenges.

For editorial and commercial work, there is always an agenda. It may be an editorial topic such as shyness or friendship (or you name it).

It may be a job for healthcare or dance wear. If you are working commercially or editorially, it is a good idea to cast kids who are outgoing but willing to take direction and especially those who love to be photographed.

I always want children to have a positive experience, so whenever possible I find it is a good idea to double or triple-cast a child for commercial advertising shoots (and for some editorial shoots), depending on the age and budget. Then, if they are cranky, not feeling well, or just not into it, we simply move to the next child with no need to prod, coerce, or make anyone feel bad.

It is helpful to work with a children's modeling agency, if the budget allows. The children there are vetted. They are not disruptive or rebellious, but creative and eager to please. There are exceptions, of course, and the younger the child, the more important it is to cast another, just in case, so it can be a good experience for all.

When families are the clients (rather than editorial or commercial jobs) I will obviously

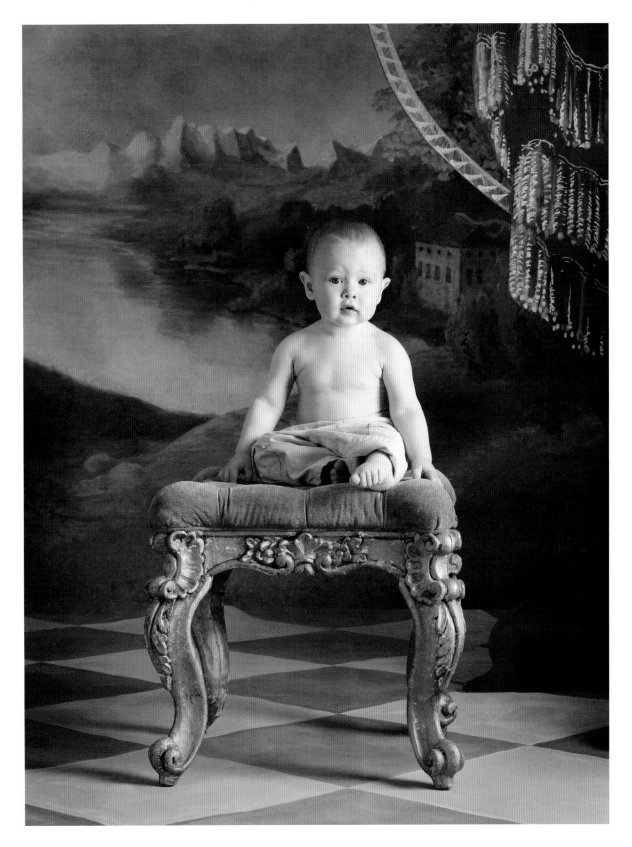

have to work with their children, whatever the personality, quirkiness, or mood. In all cases, it is really beneficial to try to engage the kids by spending a little time getting to know them prior to the shoot.

I try to schedule the shoot at the time of day that is best for the kids (rather than simply convenient for adults). We work after nap time, not before, and after eating breakfast or lunch. I ask parents to bring extra snacks, but I have bananas and fruit juice on hand, just in case. It's always a good idea for clients to bring a favorite toy, though I keep some on hand, including things that make noise. For kids ages three to eight, I also have fake money (purchased at a costume shop) on hand to elicit cooperation. Kids know it is just for fun, but sometimes they enjoy getting "paid" for doing a good job.

One technique that has served me well is to have a parent or assistant stand directly behind me (I am often sitting on the floor), just above my head with a puppet, a rattle, making funny faces, or simply talking to the subject. That gets the child looking in the direction of the camera. If a parent is off to the side of the set, the child will tend to look that way.

Toddlers who are just learning to walk will need constant attention, with someone dedicated to putting them back in place, as they invariably crawl or walk off to see the world and play with the high-priced equipment. Patience and good humor will serve everyone involved.

If the kids get tired or cranky, we take a time out for a food break. Most kids will revive after a boost in blood sugar, allowing time for a few more photos.

The child at the right was photographed for *Parents* magazine. She was one of a dozen young children I selected out of a large casting of more than 200 kids. With her red hair and big eyes, she seemed like the perfect choice. Despite the fact that she was two, she seemed well-behaved at the casting. However, when she arrived at the photo session, she raced around like a wild fire. She would not cooperate with anyone, for anything. But then, I had an idea. I sent my stylist to the local ballet shop to buy a tutu for her. Voila! The child's imagination was engaged, and she became the perfect collaborator.

Kids, no matter what age, can get bored or distracted easily during a session, so I am constantly trying new things to get their attention. For example, I have some "glove" puppets that fit on my hand to draw the child's attention. When the child's attention seems almost completely depleted, I might bring out a harmonica that I

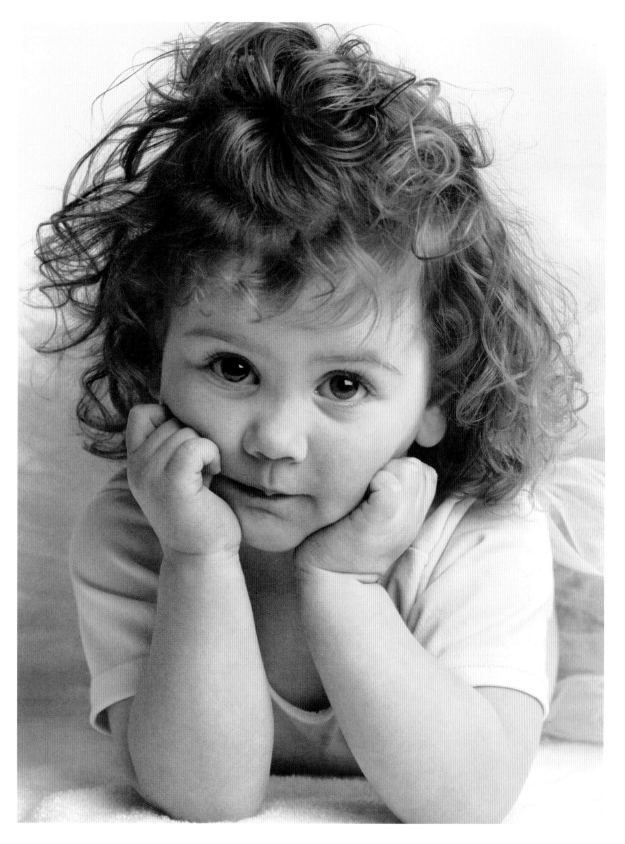

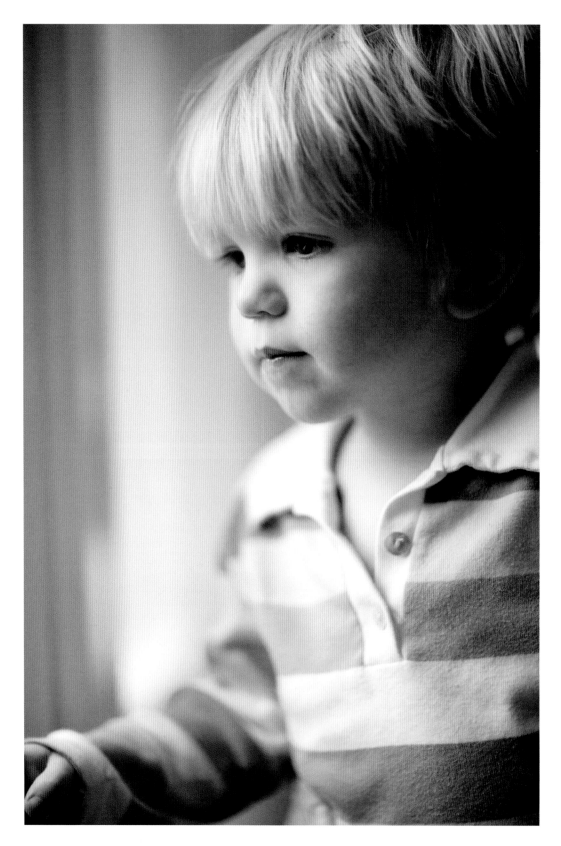

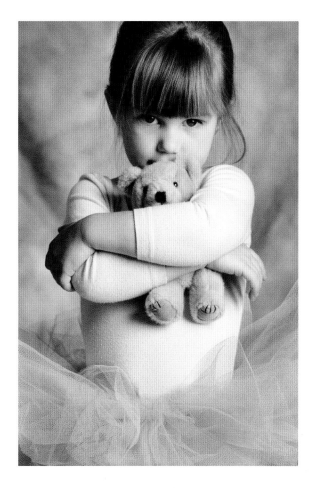

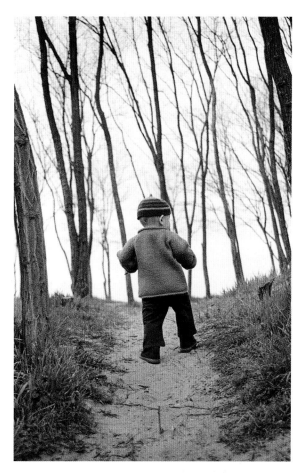

keep in my studio. It is such a surprise when I blow on it, that it changes the mood to one of curiosity and wonder, re-capturing the child's focus for a few more frames.

the perfect age for babies

A great age to photograph a baby is around seven months, when they are full of personality, can sit up, and aren't crawling away every second. Once the crawling begins, I keep a parent or assistant just off camera to bring baby back into the light.

what to wear

Clothing should be comfortable and simple. Many times with babies it comes down to just the diaper. For this, I discuss with the parent the idea of having a nice, classic cloth diaper or a simple white disposable and/or an attractive set of bottoms to go over the diaper. For older kids, I let them wear what they love, clothing that reflects a chid's personal expression or taste. I steer clients away from bold logos and clothing that attracts attention to itself.

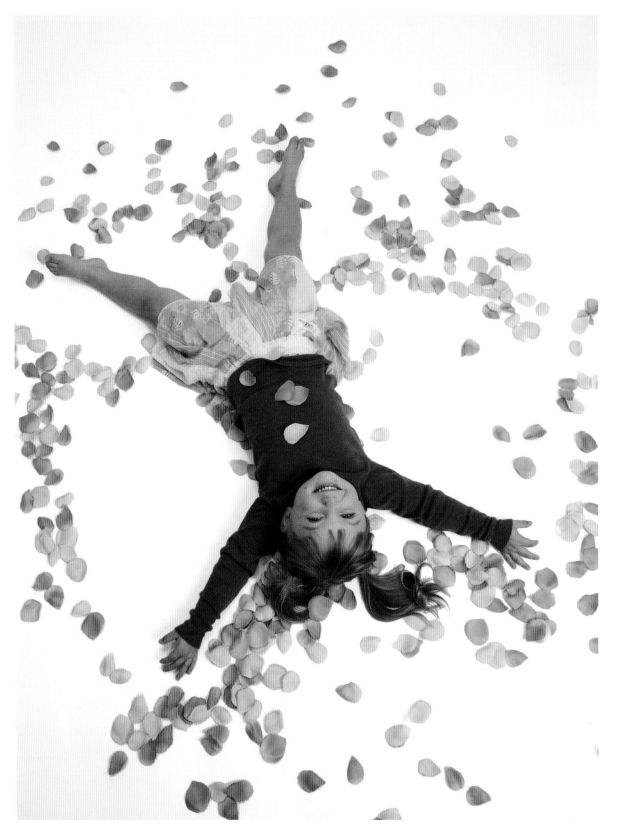

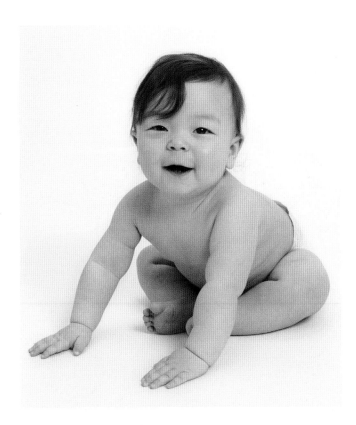

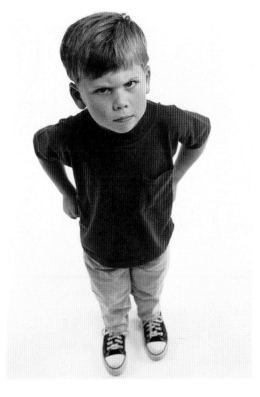

point of view

Working with kids can be an up and down affair—*literally*. Sometimes I get high above them on a ladder, sometimes on the floor to get eye-level with babies. It's always good to get a variety of choices.

Opposite page and above: These three images illustrate various points of view. For the child on the facing page, I scattered artificial rose petals on the floor so she could make angel wings. It was a spontaneous solution to a photo session that was winding down, and it resulted in the most joyful image of all. The little girl in her diaper (above left) was seven months old and full of personality. I sat on the floor, as I often do with kids, to be eye-to-eye with her. The photograph of the cranky boy (top right) was done for an editorial client to depict stubbornness in kids. I photographed him while I was standing on a ladder to make it look as if he might be acting up in front of his parent.

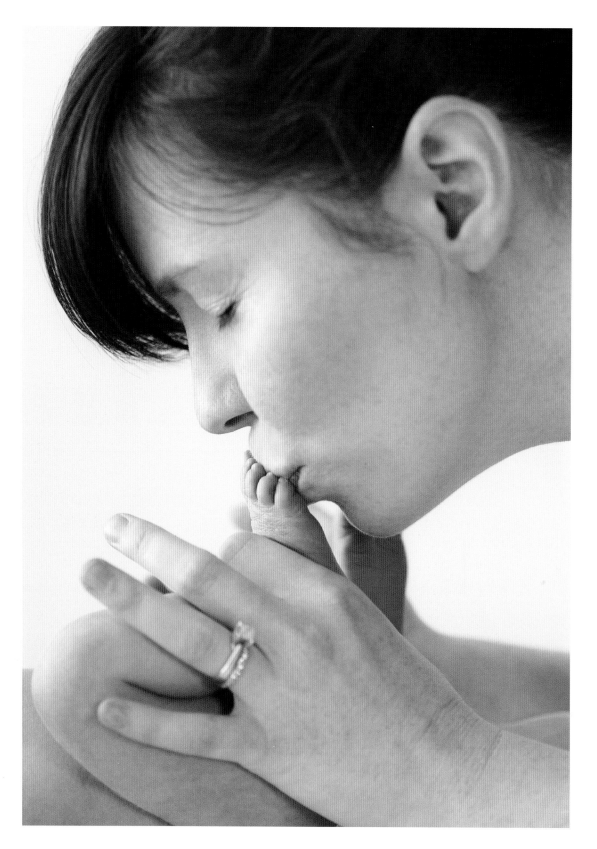

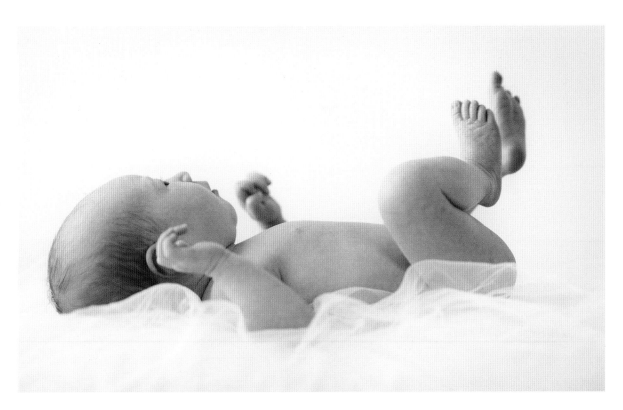

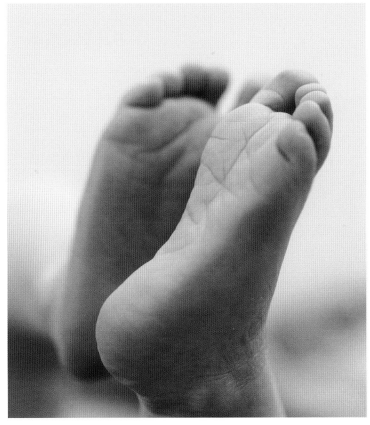

On these pages: The baby in these photos is a week old. She arrived in her carrier, rested and fed, which lasted a few minutes and then she had to nap and eat again. That's just how it is with babies.

I wanted to convey a sense of wonder in this triptych–at the mother's love for her baby, the baby in a new environment, and the detail of the tiny feet.

Everything was photographed with natural light so I could use a shallow depth of field, which gave an overall quality of softness to the images.

09 business & artist portraits

Portraits for business and the arts have some heavy lifting to do. They need to help the client make a connection with his or her professional world. That world may be the world of the CEO, politician, physician, singer, writer, artist, actor, dancer, and so on.

Though my approach to these portraits is similar to my approach to all portraiture, I feel that it is helpful to understand what profession the person is working in and what the use of the photo will be before embarking on the session. The approach to photographing an opera singer might require a more dramatic use of lighting, for example. An actor might like to show a lot of personality and expression and also have specific needs for backdrops and image crops. A financial advisor might like to show personality, but in a more subdued way.

Often portraits for these uses are done in a vertical format and composed so they can be cropped to 8x10 if need be (for headshot prints). More than likely they will be used on a website, so it is good to find out what the "feel" of the website is so the portrait can align with the overall look of the site. For example, when I

photographed an architect who was redesigning her site, I looked at her website design so we could choose clothing and backgrounds that would harmonize with her visual message.

keep the background simple

I usually choose a simple background so the viewer can focus on the subject's face and expression. If in the studio, I lean toward a light to mid-tone backdrop, using black only occasionally, as it is more difficult to reproduce in some publications, such as newsprint. If working on location or outdoors, I often use a shallow depth of field to help isolate the subject from their surroundings.

positioning hands

I am very careful about the use of hands in an image. If hands are used around the face, they should not block the features and should not create compression of the jaw or chin. Also, the nails must be in perfect condition. In certain instances, I might bring a hairstylist and/or makeup artist to work with the client. When I do this for individual subjects, I ask them to

pay the stylist directly. If working on a commercial project, I would include the stylist in the overall budget.

Props are another consideration. Often they are not necessary. Sometimes they are perfect, such as for a musician. If you are using instruments as props (or anything else, for that matter), make sure that they are artfully introduced into the composition so they help, rather than hinder, the visual flow. Also, some instruments can be reflective, and dealing with this requires knowledge of lighting. The viewer's eye always goes to the brightest place in an image, and it is the job of the photographer to control the light, composition, and meaning. In all cases, I do some images with and some without the prop so we have choices in the end.

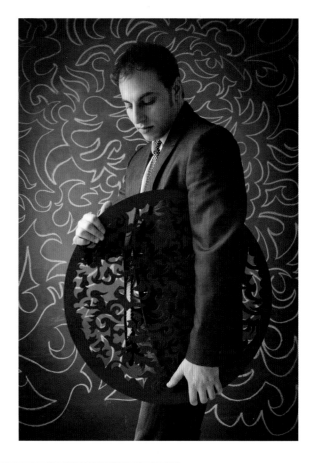

Above: Artist Jonathan Clarren holding a piece he designed. Left: Singer Jessie Marquez photographed for her album cover using strobes. Opposite page: Drummer Simone La Drummer in action.

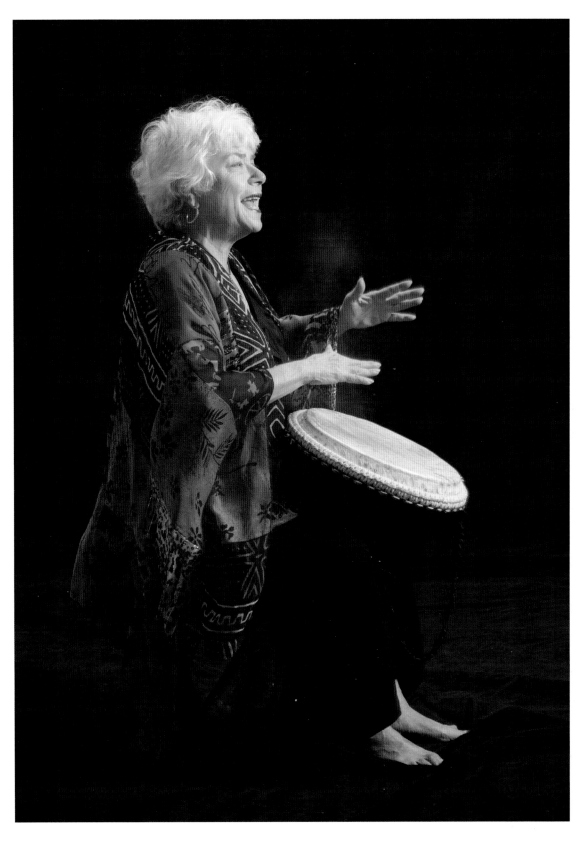

finding the mood to fit the person

Serious, pensive, thoughtful, self-assured, professorial, powerful. How are these characteristics conveyed? It's the job of the photographer to tease out the character of each person in a way that represents their work and the image they want to convey (which may be somewhat different from how they really are).

When I work with people on their portraits, we normally try a variety of ideas, from using a slow shutter speed to convey movement (as in the photo of the drummer) to using a chalkboard behind the subject to literally draw their ideas as part of the image.

Page 54: Poet Cecilia Martinez-Gill (upper left); opera singer Cristina Kowalski-Holien (upper right); artist/writer Liesl Wilke (lower left). Page 55: Poet Jed Myers.

On this spread: Artist and art critic Gary Faigin (above); Iskra Johnson, designer and lettering artist (right) and artist Lynda Lowe (facing page).

All photographs were lit with artificial light except the images of Jed Myers and Iskra Johnson, for which I used window light with a fill card.

Above: Writer Skye Moody, photographed with an octabank in the studio. Facing page: Spencer Reece, poet and Episcopal priest, photographed in Madrid by window light.

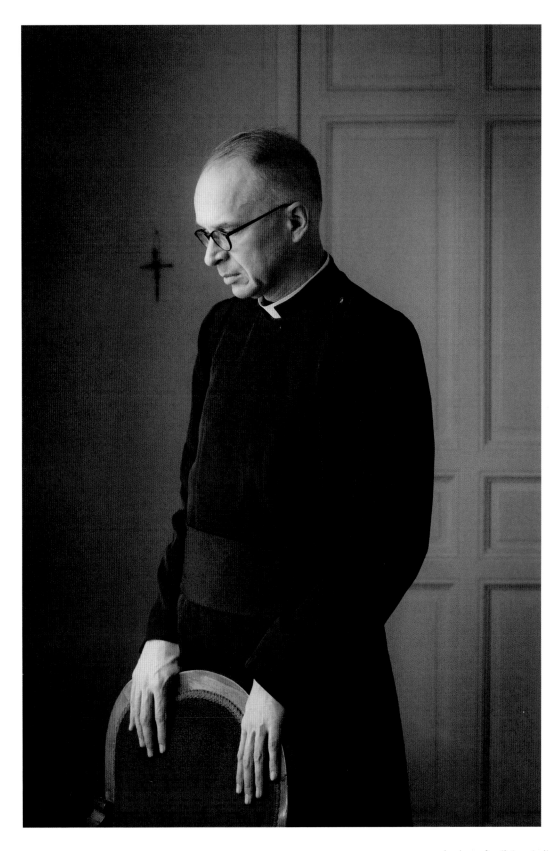

10 women

It is hard to find a woman who is not unhappy with something about herself. She may feel she is too tall or too short; her nose is too big, or hips are too wide. She may dislike her crow's feet, chin, weight, etc.

Working to help women feel beautiful is tough, but it is one of my favorite challenges, whether the photograph is a gift to themselves or their significant other, or one created for other reasons.

In a recent lighting class that I taught, one of my students commented about how he had a difficult time photographing women because they always hate how they look. And why is that? In my opinion, a photographer whose female clients dislike their photographs has:

- not gotten to know his/her subject
- not engaged them in the process
- used the wrong lens
- used the wrong lighting
- engaged in a combination of these issues

Indeed, photographing women can be a bit tricky. I half-jokingly call it "photo therapy." First of all, what is the objective? Does the woman want a fine art portrait? An abstract of her body? A boudoir photograph? Women decide to be photographed for a variety of reasons. Sometimes her therapist might send her. Sometimes I photograph women who are about to have a mastectomy and want to document their bodies before surgery. Sometimes the client wants to celebrate a birthday or create an image (or special book) for her husband or partner.

where to begin?

As a starting point, I ask people to collect images from magazines or the Internet or from my website in order to bridge the chasm between language and images. From that "homework," I can appreciate what they are drawn to in regard to mood or maybe how much of the body or what kind of clothing they want to wear (or not). I tell my subjects that this is a good starting point for communicating and the ideas are to help us communicate, but ultimately they are hiring me for my style and my ideas.

There is nothing worse than creating something the photographer thinks the client wants only to have the client explain after the

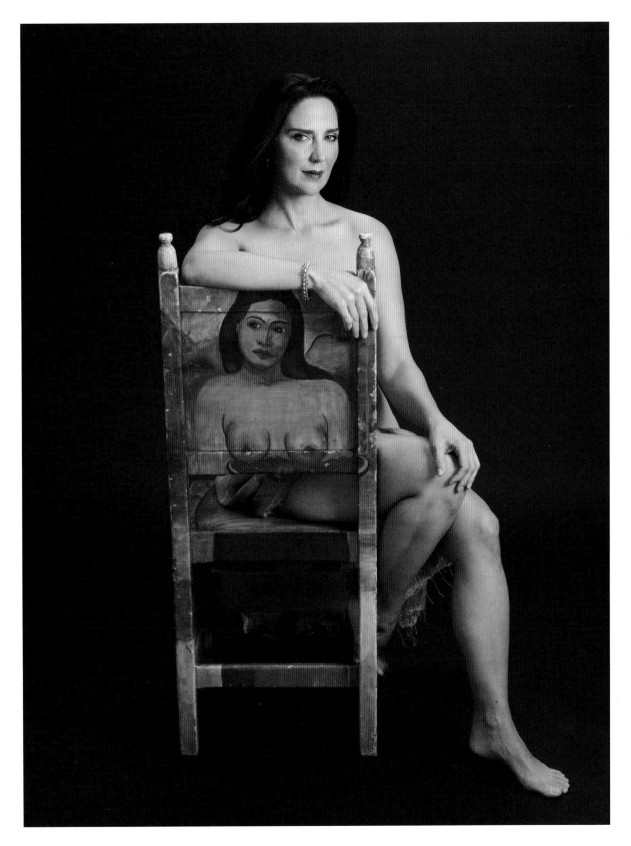

fact, when reviewing images, what they really wanted. Then it's too late.

start slowly and respectfully

If doing a nude, I start slowly and respectfully, partly for my own comfort and partly for that of the subject. I may start with a silk robe or a piece of fabric that will allow a gradual disrobing. Along the way, once I have created a sequence of photos with lighting and a pose that I really like, I will typically share the image on my camera's display.

Not every photographer works this way, but for me, this sharing does several things:

1. It furthers the communication. If she hates how she looks, I can change the lighting or pose before we go too far in the wrong direction.
2. It helps create trust.
3. It allows a sneak peek at the images so the client is not so surprised at the end.

For private commissions, one might hope that the outcome of the photo session would be the sale of prints, but that may or may not be the case. The photographic process is sometimes a goal in itself. It can be a wonderful and healing experience for someone to be seen as beautiful. Whatever the reason, for me, at least, it is an honor to be of use with my skills, to create a memorable photo of the body and spirit.

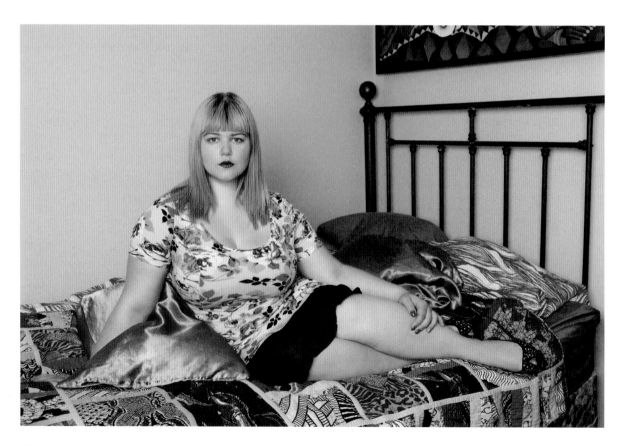

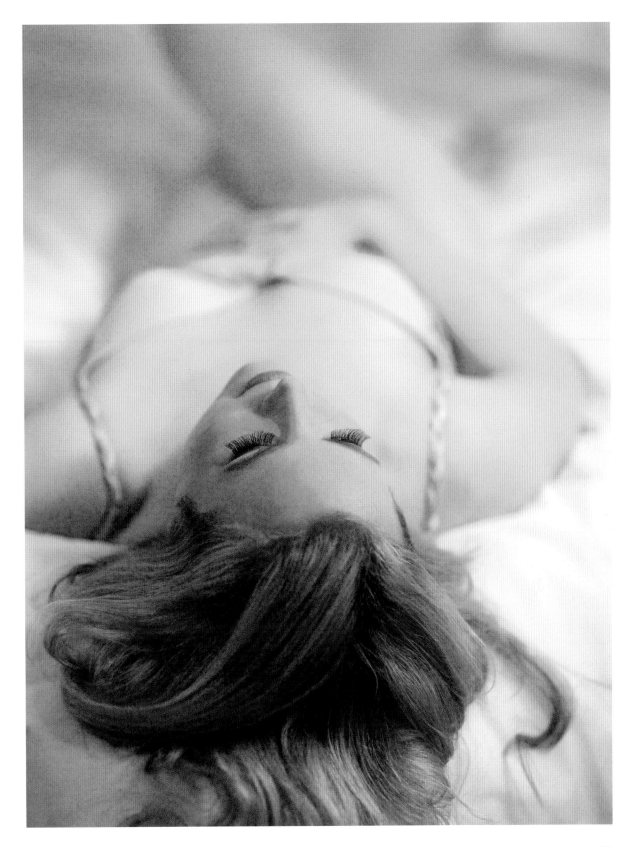

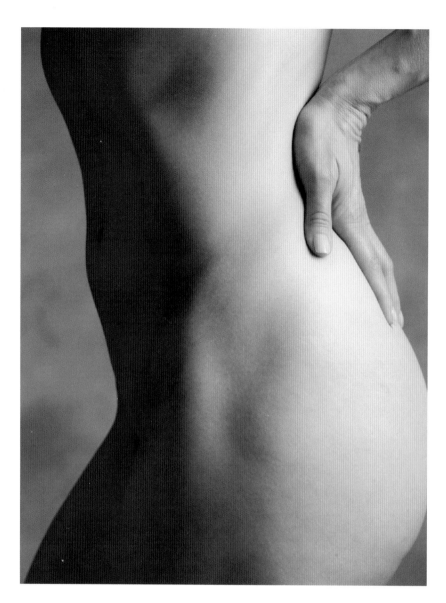

Page 61: Portrait of a woman prior to mastectomy. Page 62: Portrait of a woman in her bedroom. Page 63: Portrait done for a fortieth birthday. Pages 64–65: Portraits created for my book about women and body image, This is Who I Am.

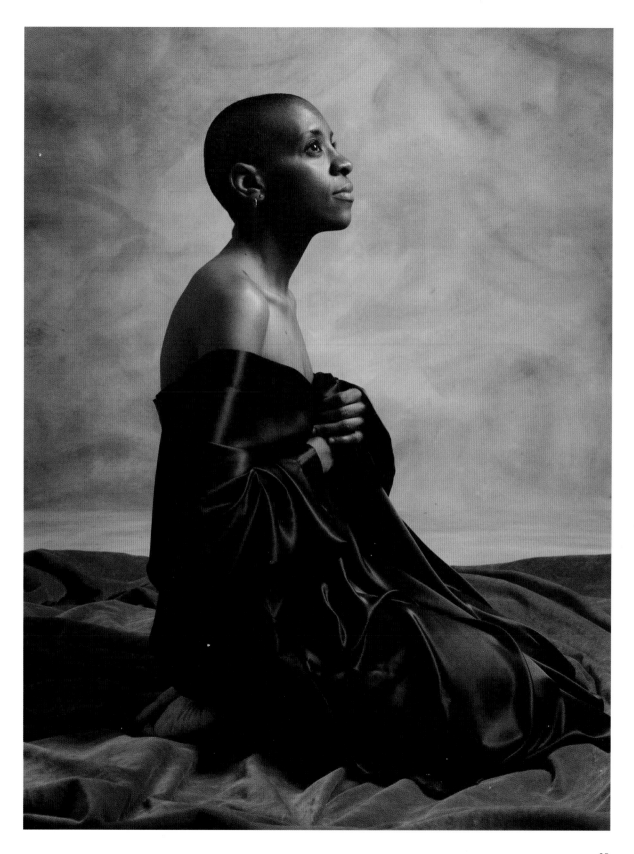

11 teens & high school seniors

Every portrait session is important. But the senior picture ranks up there with weddings. Teens are often savvy consumers of media. Especially girls. They know fashion. They usually understand styling and have researched images they like. They may have a vision of what they wish to look like—and what their friends are doing with their senior portraits.

High school seniors are often very busy people who are studying, trying to apply for college, and are involved in after-school sports or other activities. But, as with every portrait, I try to talk to the person before the photo shoot.

During the initial phone conversation, I may ask them to send me a selfie of what they look like now, as well as some samples of images they like from the Internet or that they snap from magazine ads with a cell phone. I also ask them what photos on my website they are drawn to, so I can make sure we are headed in the right direction.

Do they want casual images? Fashion? Sporty? Depending on the weather, I may schedule a session that starts indoors and then, after

we have taken some time to work together to establish a relationship, we may go outdoors for a second "look"—depending on the weather, of course. I scout locations ahead of time at the time of day we plan to photograph. I am open to spontaneity but feel it is important to have an organized plan that I can veer away from, if something better arises.

Aim for variety: horizontal, vertical, wide and close-up.

During the session, it's good to get some vertical close-up portraits for the yearbook and as gifts for relatives, but it's also good to get some scenic shots in a place that is meaningful to the client.

These shoots can be a lot of fun, kind of like doing a fashion shoot without the pressure. I always share images with the client to make sure we are going in the right direction. These are photos that they, their family, and friends will treasure for decades—if not generations—to come, as I still treasure photos of my sisters and friends from that important milestone.

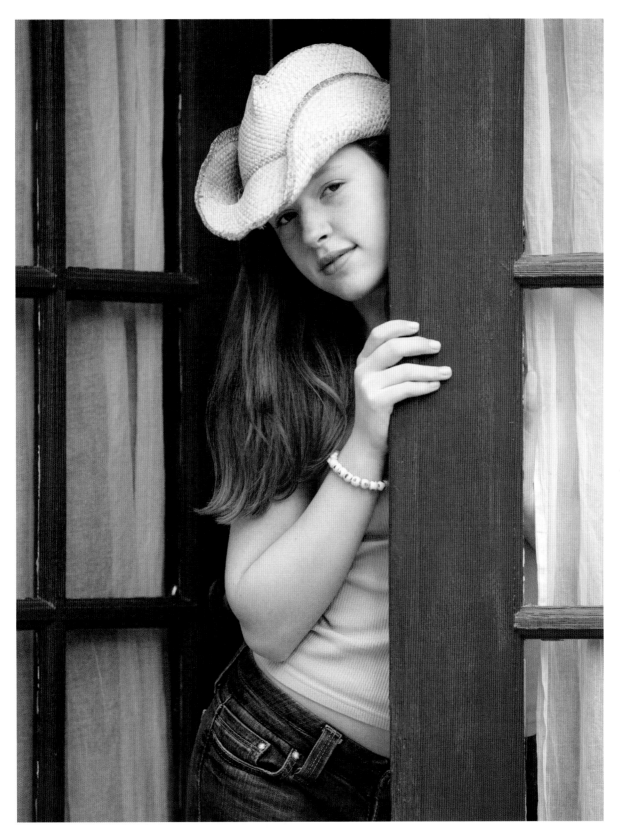

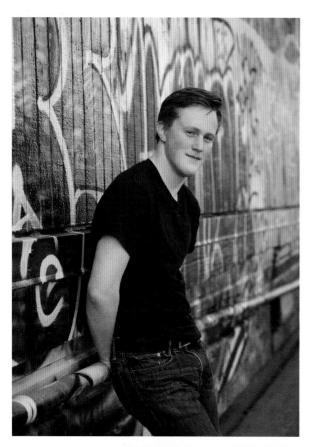

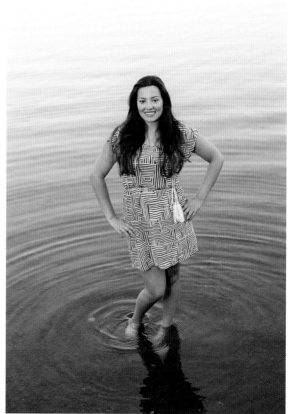

*Previous page:
A girl in her
hat. This page
spread: A boy
in a grafitti-
covered
alley; a senior
portrait in
a lake at a
nearby park;
in the studio
with strobes; a
window light
portrait.*

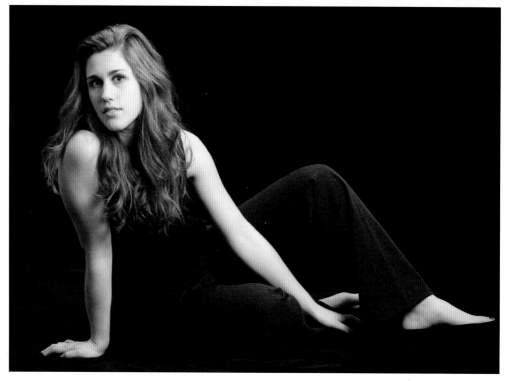

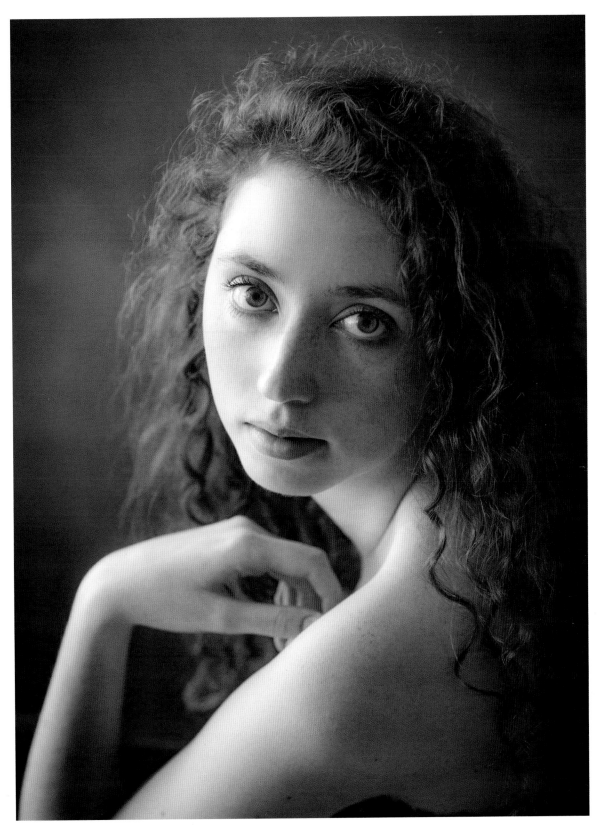

12 two people

One person can provide a plethora of possibilities. When photographing two people, it's possibilities squared. Photographs of two people can include the newly married, the long-married, parent/child, friends, siblings, people in work relationships and people who have just met for the first time.

Each situation is different and requires some understanding of who is in front of the lens and an assessment of how they might interact with one another in a truthful but compelling way. This is where the photographer's job of wearing many hats comes into play.

Start with the basics. It is good to talk to the subjects as they sit next to each other so you can get a feeling for how they might interact—for example, the way they lean in or look at each other or make jokes. Observe and learn. I also ask them what they have in mind, as a photo will represent their relationship. I sometimes ask people to demonstrate for me, without the camera, how they would interact, stand next to each other, sit, etc. This helps warm things up and gives you a decent starting point. (*Note:* The business relationship photos will likely be more formal in appearance, but it is still a good idea to have a conversation. It helps get everyone relaxed and involved.)

Once I have a sense of whom I am working with, we figure out the clothing they have brought along (if there are options) and then just begin. The initial photos are just a starting point and not necessarily the final product.

If we are photographing on location, I might walk the subjects around to look at a few possibilities to see what they look like through the lens before deciding on where to begin.

As always, I consider composition: arm positions, hands, color of clothing, background colors, eye contact (one or both people or neither) as ways to engage the viewer of the photograph. One thing I tell my students is that it helps to study the Masters, both in painting and in photography. What do they do that works well? I recommend creating a collection of images to learn about form and composition.

Facing page: Dancers from the New York City Ballet photographed at the Lincoln Memorial in NYC.

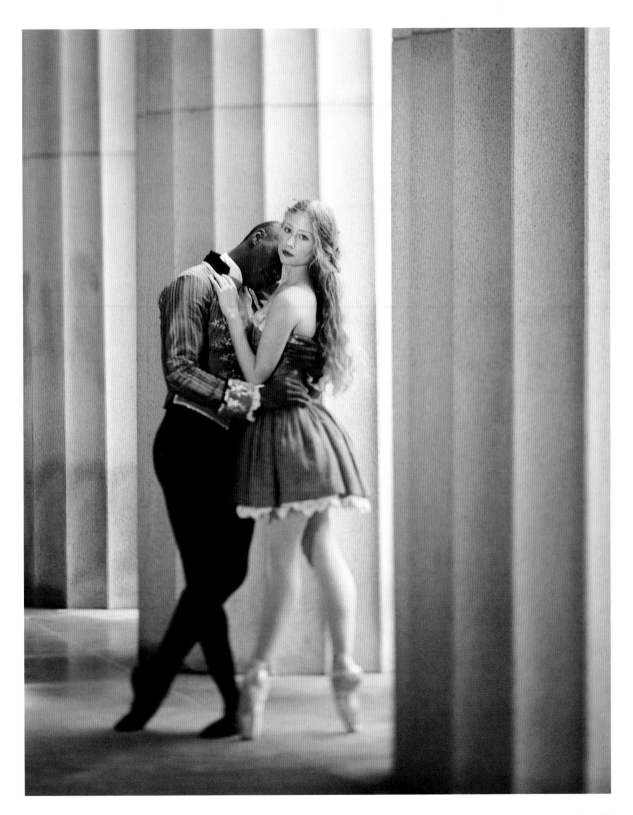

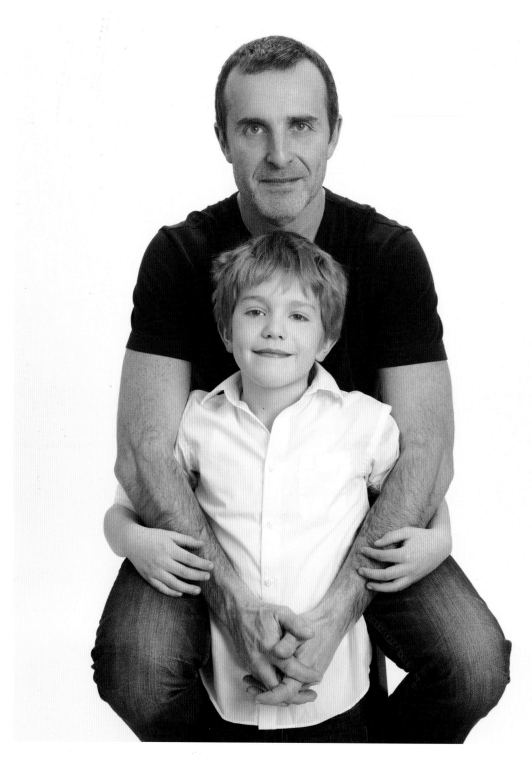

Above: Father and son. Facing page, top: Mother and daughter. Facing page, bottom: Pregnancy photos for a couple. Page 74: Two sisters. Page 75: Mother and daughter.

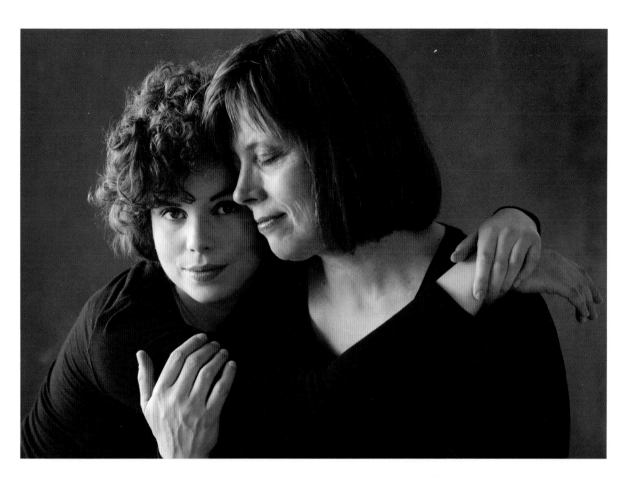

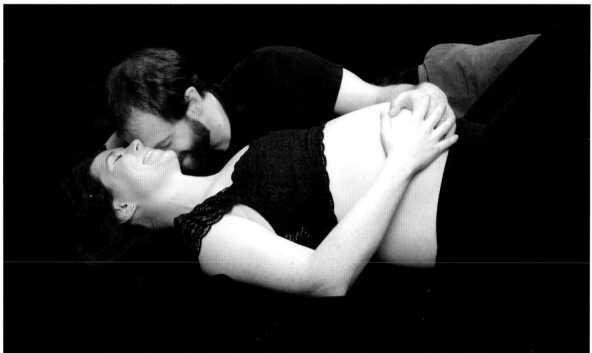

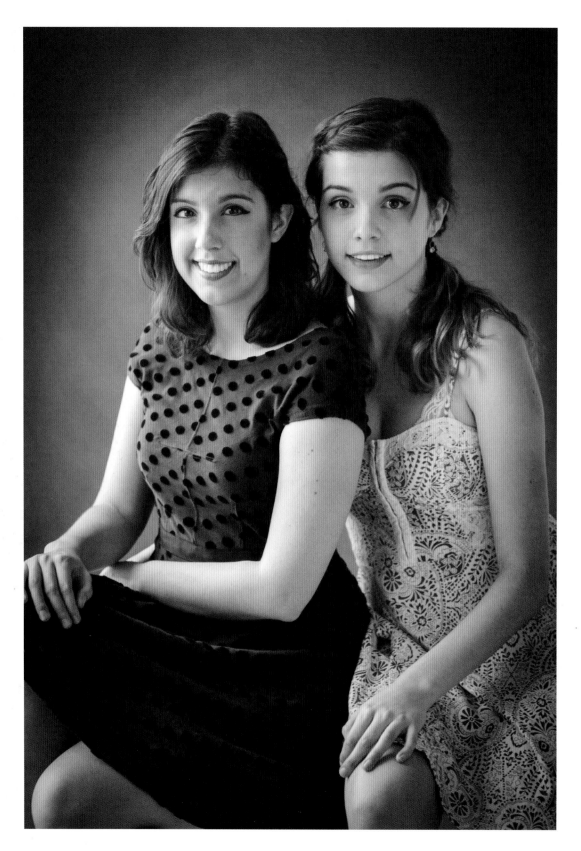

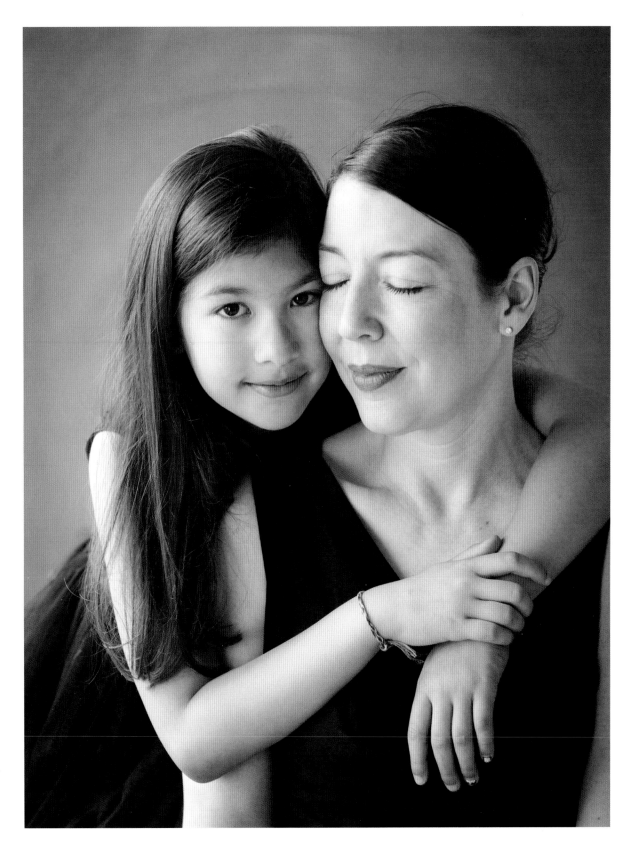

13 groups

As with photographing two people, working with a group demands that the photographer gain some understanding of whom he or she is working with. Are the people related? Are they in business together? Is there someone in the group who has a great sense of humor? The more warmed-up the group is, the more personality the photographer can coerce out of the session, even if the final photo is more serious. I always aim for a spectrum of expressions in any work I do, including groups.

One of the biggest challenges of working with a group is deciding on how to position people in regard to height. I once had a photo session with six people that included two people over 6-feet, 5 inches and one person who was 5 feet tall. What I normally do in a case like that is have a tall stool or two for the tallest people so they can sit down, surrounded by the people who are shorter. That way the difference in the height of the heads is reduced.

Another challenge is clothing. A bit of pre-planning can help. I ask people to bring more than one shirt or sweater in a color range—for example, earth tones or grays and blacks. It

might depend on the purpose of the image. For example, a pediatric office might want more colorful clothing, while a financial office might want a range of gray to black. When I get people in front of the camera and determine the best positions, I can ask them for changes in clothing to balance out the composition. For example, not to have all dark on one side and all light on the other.

It helps to think of musical notes when positioning subjects.

When it comes to positioning groups, I often think of music notes. When the heights of the heads are like notes in a melody, the photo has a more interesting quality than when the subjects are lined up in a row (there are exceptions to this, of course).

Once the positioning and clothing have been figured out, the third leg of the tripod (so to speak) is the lighting. Lighting a group can actually be pretty simple. Keep the height of the light (meaning the light itself, not the top of the softbox) at the head-height of the tallest

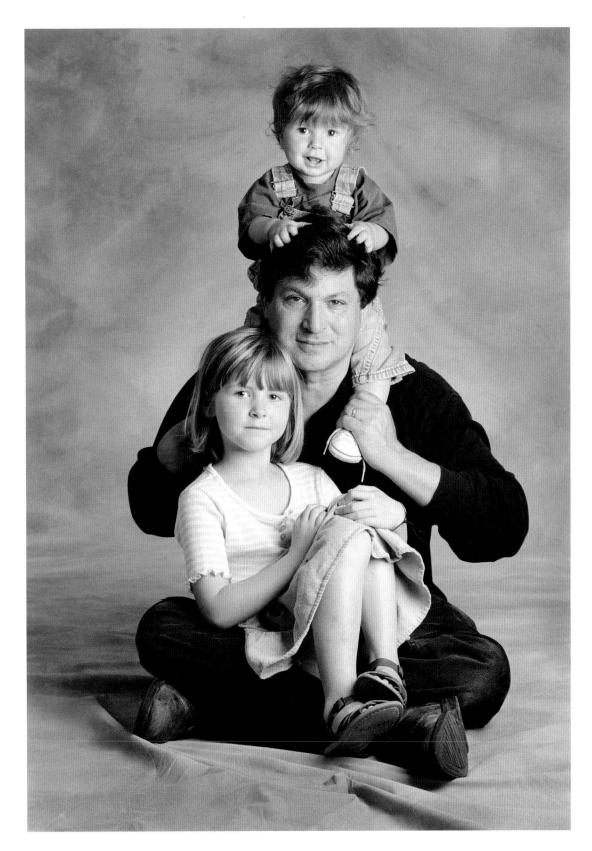

person. Position the light a few feet in front of the group off to the side and then turn it so it skims across the entire group with a slight direction to the person at the opposite end of the group. That way everyone will be evenly lit. A fill card or another light may be added at the shadow end for fill. I prefer a card to a second light when possible.

Other considerations for lighting include hair lights, background lights and, if working on an interior location shot, lighting for the environment. It is a good idea to have the lighting worked out before the group arrives. In professional photography, this is called pre-lighting. The light may need to be tweaked a bit when everyone is in place, but overall it is essential to be organized and prepared so as not to wear out the cooperation of the subjects.

When I have the luxury of working with a group for a decent amount of time, I might mix up the positions of the individuals after photographing the first setup to give them some options.

Page 77: Father and kids. Below: For this photo of a pediatric group, I asked each physician to bring a couple of shirts in a certain color range. The babies were a perfect addition. We had a third baby on hand in case one had a meltdown. Opposite page: I lit the subjects with a bit of strobe light, using a slight warming gel to add warmth on a very gray day.

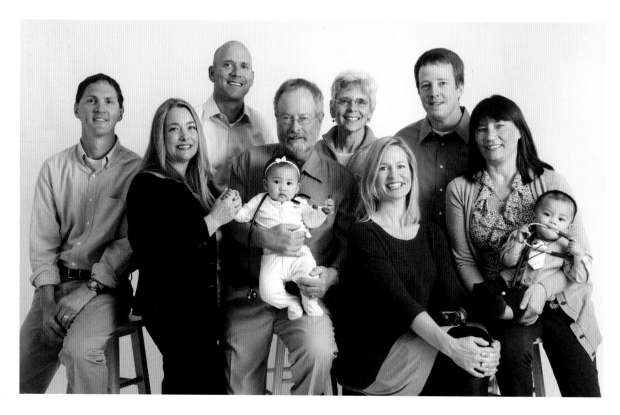

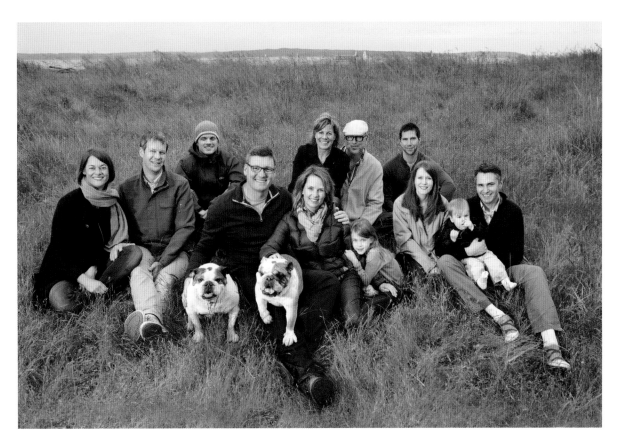

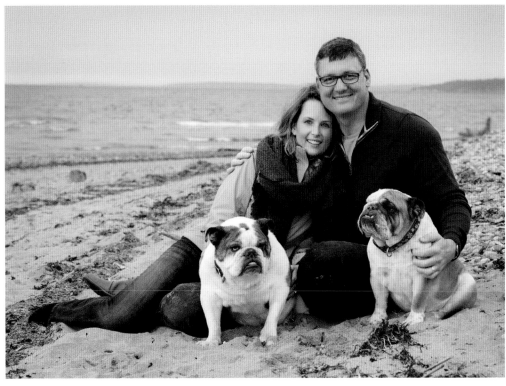

The family on these pages is one I have been photographing for many years. As the kids grow up, it is interesting to see their personalities and relationships unfold. They are all at ease with the camera now. With the white backdrop behind them, we can focus on the personalities and body language. The boy is a great character whose body language adds a bit of quirkiness to the arrangment.

The photo sessions are always fun, with time to explore different outfits and time for each child to have a solo session in front of the camera. I don't ask them to dress any certain way–but mainly to dress to express who they are at this time of life (though I certainly offer my opinion about the clothing choices they bring). It makes for much more authentic and expressive images, something that they can really reflect on when they grow up and look back at their lives.

If we take time to play, the results are always a view of authenticity.

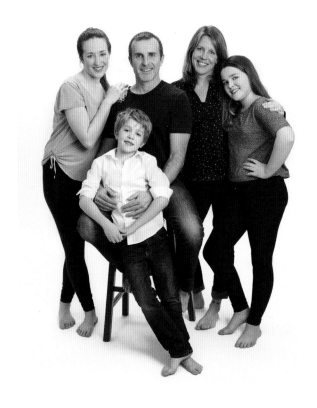

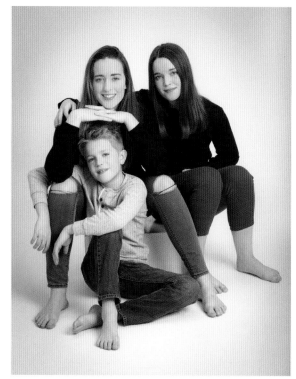

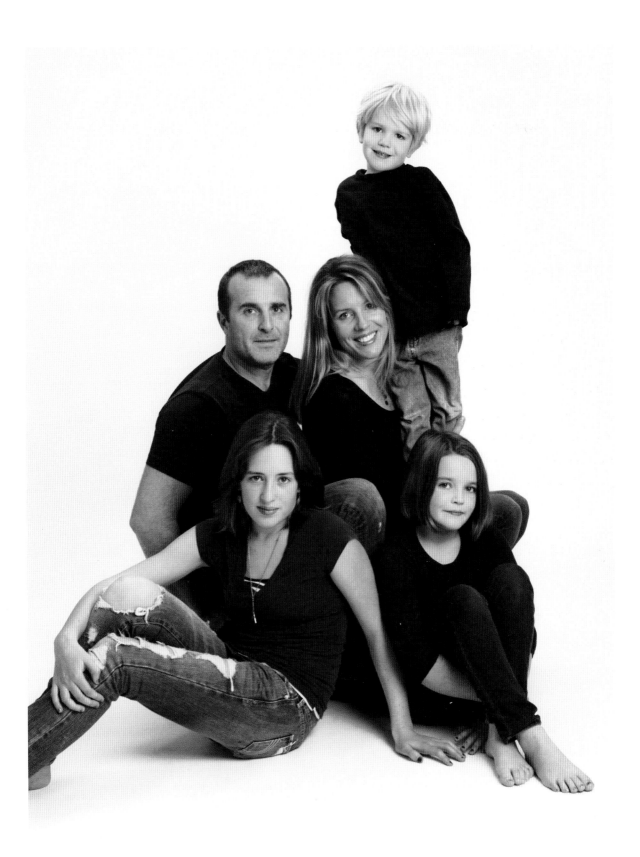

14 editorial

Editorial portraits can run the gamut from straight-ahead photographs to very illustrative imagery. An example of an editorial portrait would be one created for a magazine or newspaper feature article about Alzheimer's disease or aging. Sometimes the editorial portrait is used as a single image; other times, multiple photos are used to illustrate a story, in which case the images need to work together. For example, a lead shot may be accompanied by others that may be close-ups, details, wide-angle, scene-setting images, etc.

Photographers vary in their styles, and this is often revealed in how editorial portraiture is undertaken. Some photographers specialize in humorous over-the-top portraits (e.g., a coffee importer buried up to the neck in coffee beans or a dog-walker surrounded by dozens of dogs). Others create deeply dramatic images. My personal preference is for depth, drama and, when possible, something unexpected.

Sometimes there is little difference between an image created as an editorial illustration and one created for an ad campaign. However, editorial portraiture is often more about the person, while advertising tends to be more about the concept. If assigned an editorial portrait, I will talk to the art director or photo editor to learn about the story, about the subject, and what the story is meant to convey. If the article is written, I will ask to read it. If not written, I will ask to speak to the writer to get a sense of what they know.

planning is key

I then try to imagine some approaches as to how to put together the photo shoot. We discuss if there may be a size or shape of image they have in mind for the layout. Do they want a more conceptual illustration or a more direct portrait? I ask to be connected with the subject so I can "meet" them on the phone as well as explain and arrange for the shoot.

Often I will sketch my ideas, planning out my creative approach, lighting ideas, and problem-solving in advance.

If the budget allows, we may include a makeup artist/stylist and a photo assistant

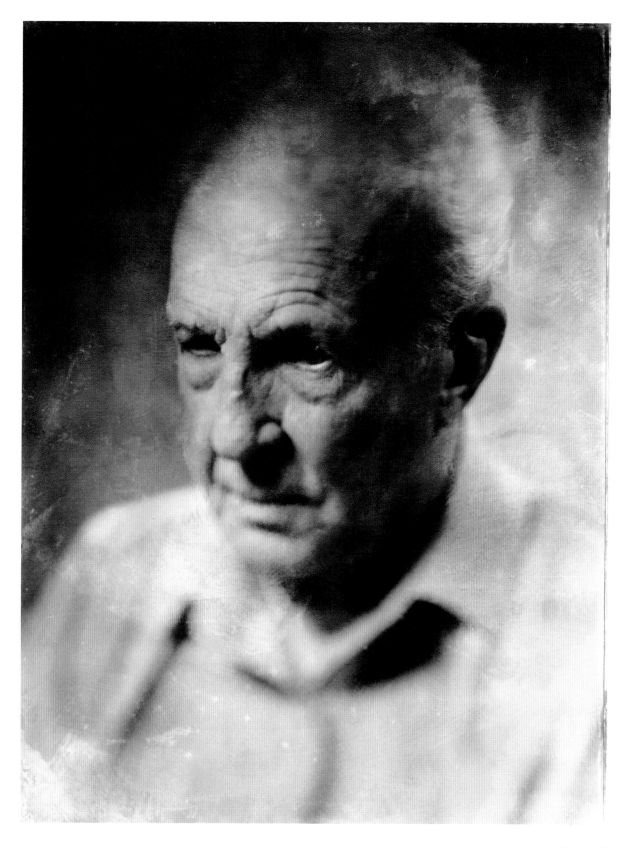

on set. Also, wardrobe needs to be discussed. Sometimes the subject will just wear what they wear (if they do, ask them to bring clean clothes on hangers) and other times we may need to purchase something (or have the stylist do so).

Budgets for editorial work are usually small as compared to advertising. The advantage of editorial work is that the photographer has more leeway to be creative. Editorial shooting is a wonderful opportunity to create work that will be seen by many, and it will have the photographer's photo credit attached, which happens infrequently in advertising/commercial work.

Page 83: This portrait was made to illustrate a story about Alzheimer's disease. I purposely eliminated the catchlights in the eyes when I lit the subject. Below: Childhood Innocence is a collage of flowers and poetry. Facing page, top: This photo of a nun was done for a story about cloistered Carmelite nuns. It is a pan shot to show a sense of movement and joie de vivre for the novice, Sister Elizabeth. Facing page, bottom: This portrait of two women was made to illustrate a mentor/mentee relationship, so I asked the women to write about their relationships with each other, combining that with the studio portrait to add depth to the image.

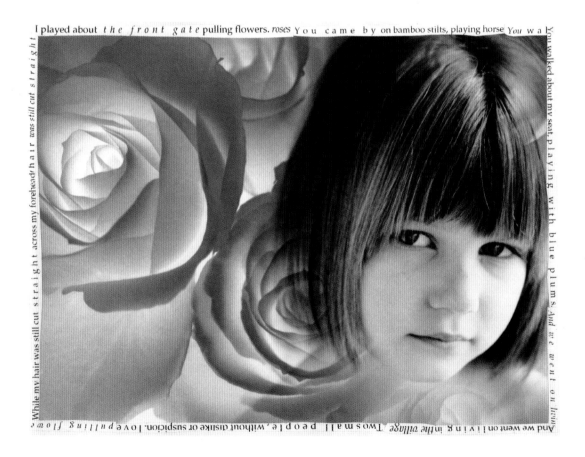

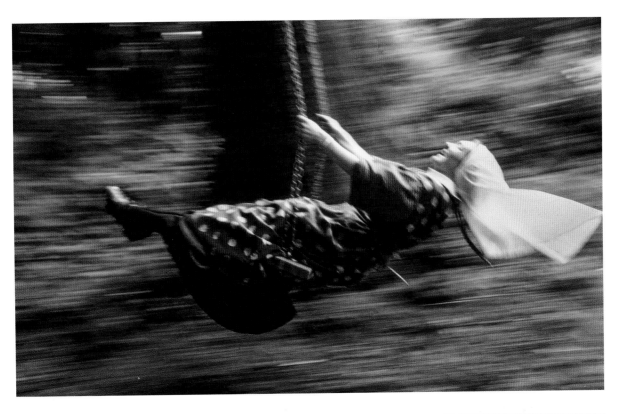

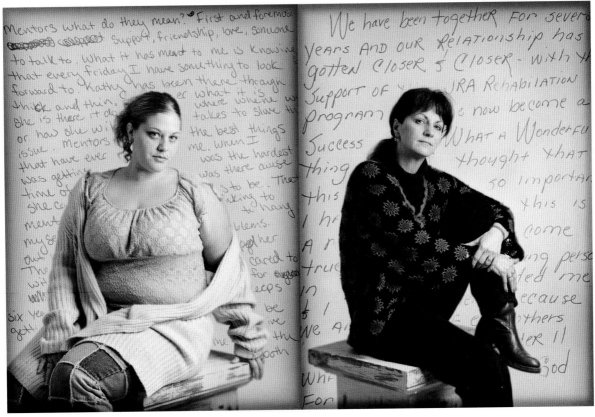

15 commercial

Working in advertising means creating images that convey the message of a client. In some cases, the people in the photographs are actors or models who depict a character, such as a doctor or businessperson. In other cases, the person in the photograph is a non-model—a real person who is representing him or herself.

The difference here is that models and actors are trained to portray different characters and emotions. The job of the photographer (or director) is to convey what is needed. The model/actor should be capable of nuances of expression and body language that can be elicited through suggestions and further refined along the way. However, even though we are working with people who are trained in what they do, making a personal connection, getting to know whom we are working with, and connecting with humanity and humor are ways to get more character out of the photo shoots.

When photographing people who represent themselves, the photographer still must work to help the subject to relax and be themselves, similar to regular portraiture. An example of this is work I did for an ad campaign for Children's Hospital in Seattle. We worked with kids who were former patients. They were not models or actors. So it was a matter of discovering what they loved to do (which became part of the photograph) and then allowing them to have fun and be themselves in the context of what we were trying to achieve. In the end, it was about treating the kids with respect and expecting the same from them. And, indeed, they were great.

Communication is key—with the art director, support crew, and models.

Photographers not accustomed to photographing for advertising are often surprised to see the amount of work involved. Every single detail has to be thought of in advance: the budget, the set (if in a studio or on location), weather contingencies (if outdoors), every piece of equipment, travel costs, directions to the location, location permits, insurance riders, clothing, hair, makeup, model releases, and catering. Communication is key to keep the job on budget and flowing smoothly.

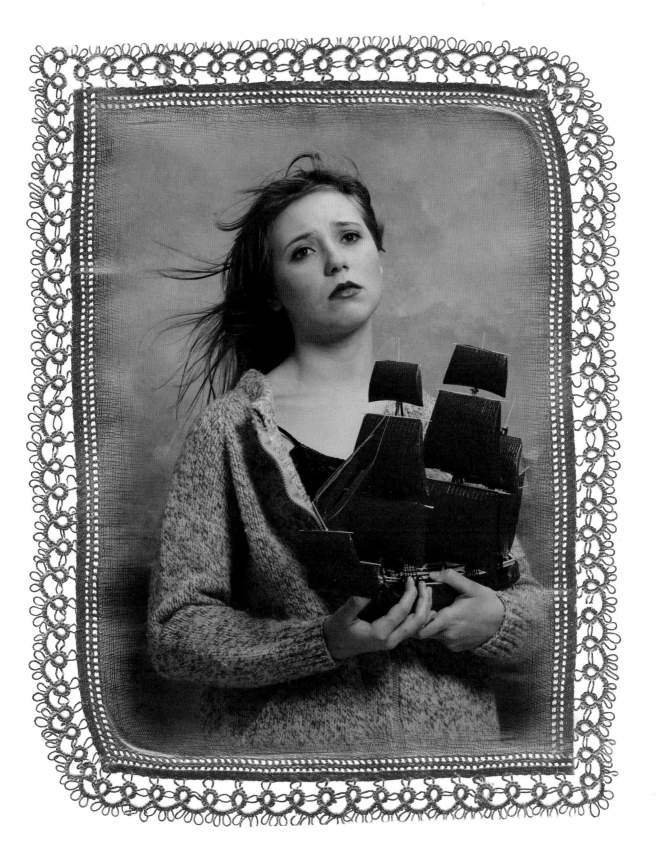

For larger jobs, a producer is often hired to pull together the details outlined above. For smaller jobs (and sometimes large ones), it often falls to the photographer. So besides making the photos, all other details must be dealt with.

When the details are covered, the lighting set up is ready, and the hair, makeup, and clothing are in place, it is time to focus on creating an amazing image.

In planning for advertising, the art director may have a layout that includes type. The layout is a very important consideration when setting up the photographs.

Something that has worked well for me is to help models and non-models alike to understand what I have in mind. For example, the story, emotions, and mood, so their work with me comes from a personal place. This works better than merely suggesting they look this way or that, tilt a certain way, or feign a laugh.

I will create a story with them, ask them to draw on their memory of an event in their lives that makes them feel a certain mood: laughter, joy, sadness, wistfulness, uncertainty, etc. Perhaps the model can imagine an event from childhood or leaving home for the first time, the death of a friend, etc. Allow for a few moments of reflection, then proceed with the session. This technique will help the model access emotions that are real or true to life. Another strategy I use is to share the image on the camera. If I am explaining something I want done differently, the model will become my collaborator in creating a meaningful image.

When working in advertising, it is common to have an art director on set and possibly the client and the account rep from the ad agency. The photographer may have a lot of people he/she is working with, but in the end, it is up to the photographer to get the image that everyone wants. If the stylist or art director want to suggest something they want the model to do differently, they need to run that request through the photographer rather than directly to the model. Otherwise the subject will become confused and the images will show it. I am open to the ideas of others, and if the timing feels right, I may modify what we are doing to try another angle, expression, garment, etc. It is all in the interest of getting the best-possible image.

professional organizations

For photographers who are new to the business of commercial photography, there are some professional organizations that may be of use to you, which I address in chapter 18. One can join the organizations as a student, assistant, or professional. They are great opportunities to network and learn.

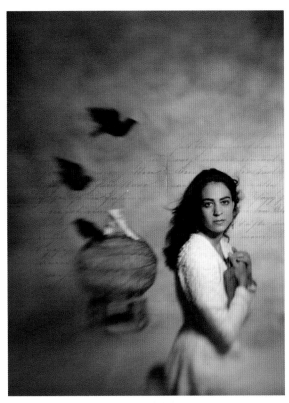

The photograph on page 87 was created for the Seattle Opera to illustrate The Flying Dutchman. *It is an example of working deeply with the model to create a feeling of longing and sadness. Left: This image was created for a theater company. Note the space for type above the actor's head. Below: This photo was made for the Puerto Rico Department of Tourism to show the beauty of the countryside.*

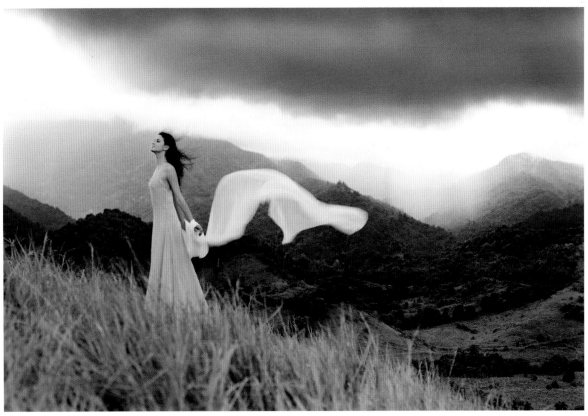

The images below and on the facing page were taken for the New York City Ballet's annual campaign. It was a complex job that required finding and permitting multiple locations, scheduling dancers, choosing costumes, and dealing with weather.

The locations in Long Island and New York City were scouted weeks ahead of time by a location scout who was well versed in the area's many possibilities. I went to New York in May, when the weather was incredibly hot, to review the locations, select dancers, and choose costumes. When I returned for the shoot in June, the weather was cold and rainy. Fortunately, we had scouted some interior options and gotten location permits to work under cover, just in case.

We hired a large RV to house the crew, the costumes, the dancers, equipment, food, stylists, client, art director, etc.

This was one of my favorite jobs; I was asked to develop the ideas, choose the dancers, select the locations, and pick priceless costumes from the incredible costume vault at Lincoln Center in New York City. I sketched my ideas ahead of time, with my awareness of locations, dancers, and costumes so we could be organized. While at the locations, there was room to experiment after the planned images were finished.

The bottom-left ballet image was made with a mix of strobe and natural light; the other images were shot with natural light. Though there were swans and ducks at the pond where the image on the facing page was made, they wouldn't cooperate, so the swan was added in postproduction.

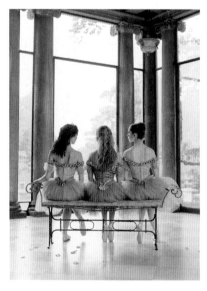 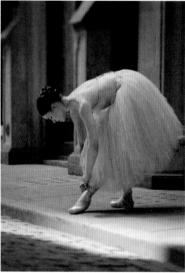 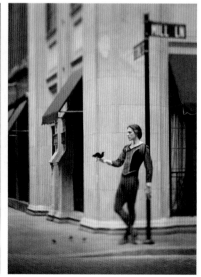

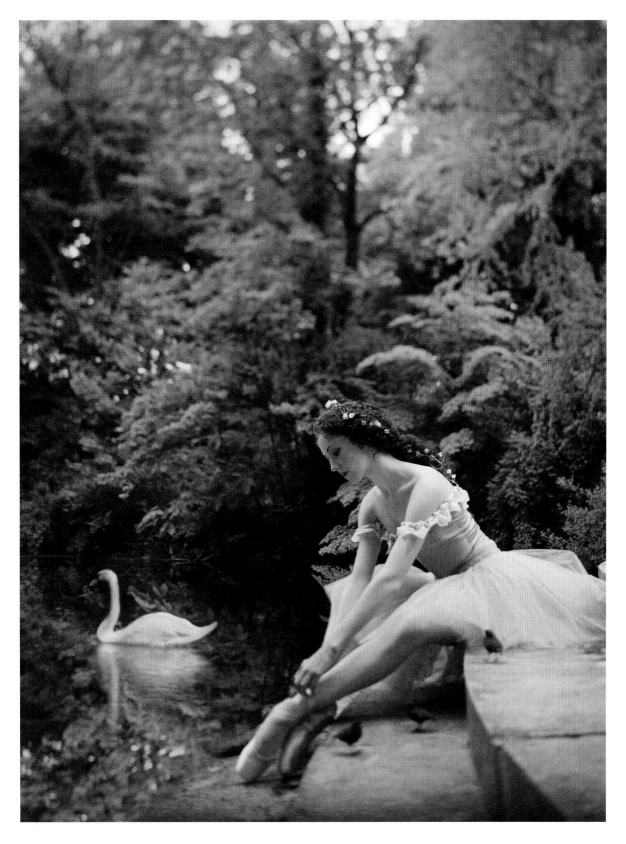

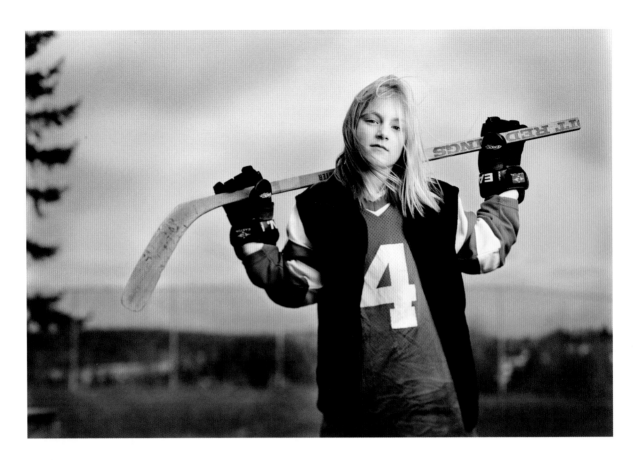

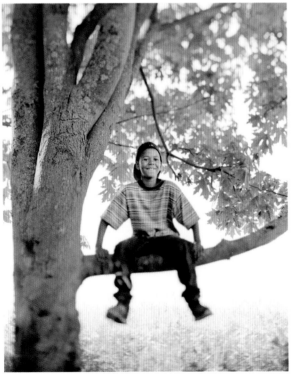

Above: This is one of several scenarios shot for a campaign called "Girl Power" to celebrate the fiftieth anniversary of Mattel's Barbie doll. At the time the photos were taken, it was about 33 degrees outside.

Left: One of several children photographed for a hospital campaign about children who had benefitted from their services.

Facing page: Portrait of Bronka Sundstrom who, at the time this was taken, was seventy-nine years old and the oldest woman to summit Mt. Rainier in Washington State. The photo was done for an energy company featuring images of people with "energy."

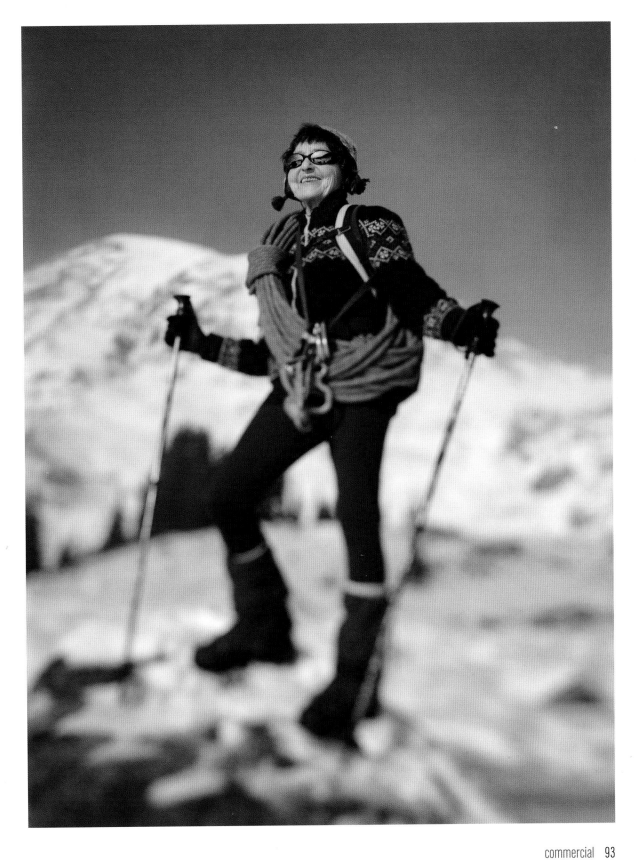

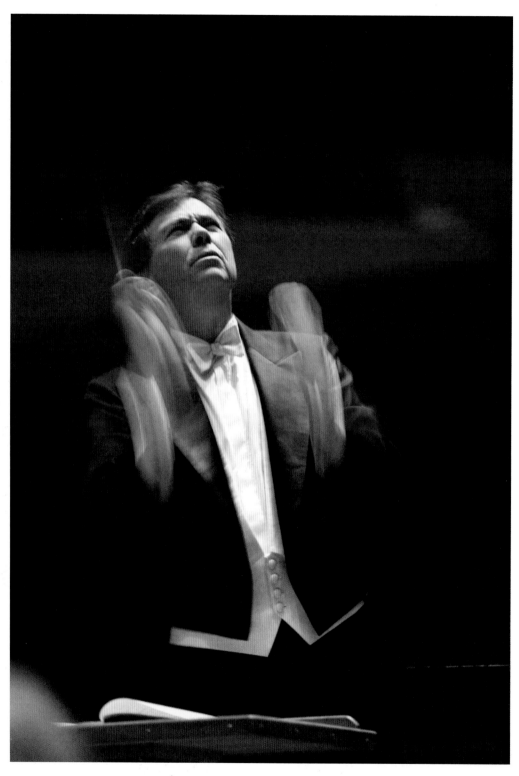

Above: Portrait of maestro Gerard Schwartz made using a slow shutter speed. Facing page: One of serveral images created for the Seattle Symphony's 95th anniversary ad campaign.

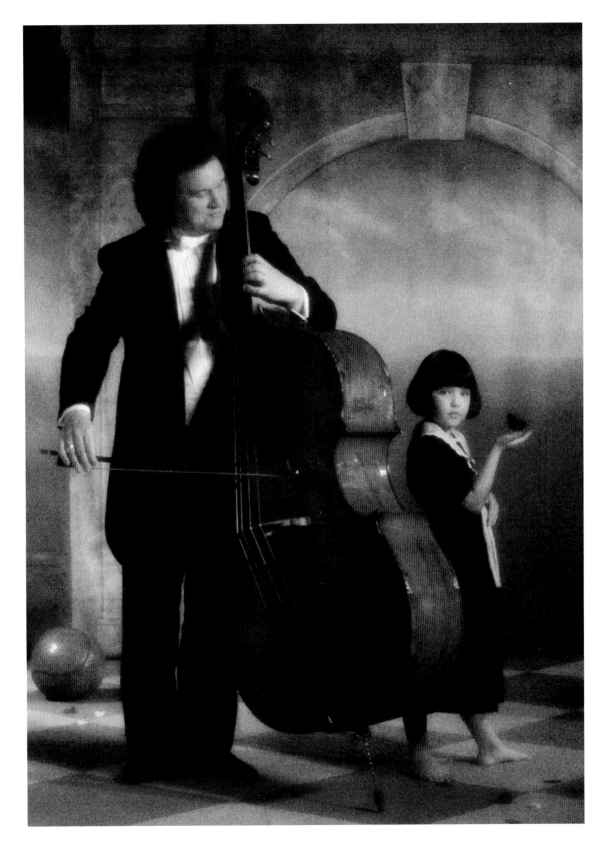

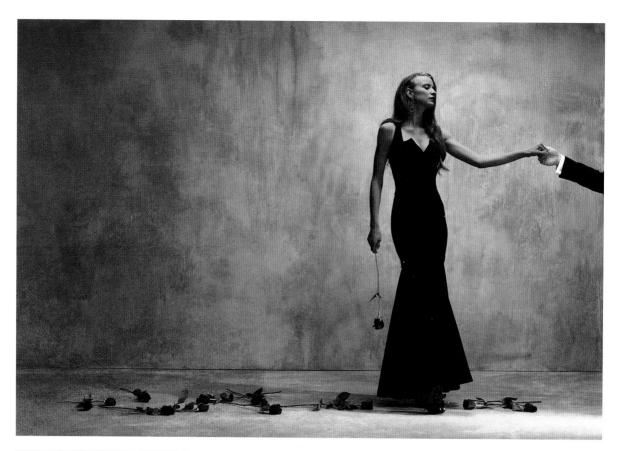

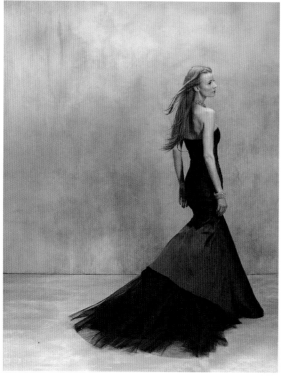

Above and left: Two images (of many) that were created for a new, high-end shopping center depiciting some of the designer clothing and other products to be carried at the stores.

Right: A self-assigned image that became a greeting card image and part of the Getty Images collection. It was taken on a cold February day, the kind of day that lends a pink tint to the afternoon sky. It was photographed with a 4x5 view camera using selective focus, which accounts for the fact that, while the face is sharp, the balloon and her feet are somewhat out of focus, making it look as if she is lifting off the ground.

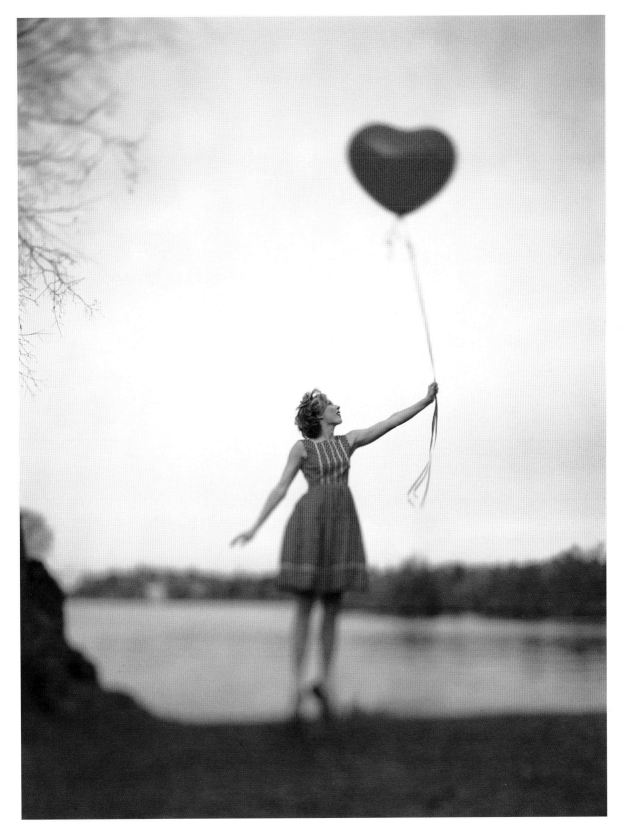

16 pets & their people

Pets are similar to babies when it comes to photography. What I like about photographing pets (and babies) is that once they are comfortable with the situation, they are completely themselves—until they decide they are done. Unlike adults, they are not concerned about how they look, how big is the nose, how heavy the chin, how wide the hips. If I am able to engage them so they are enjoying themselves, things will go fine.

I prime the pet owner about what to expect. I ask the owner to bring favorite toys or treats for the dog or cat. If the portrait will show the pet owner and pet together, it's up to me to get the attention of both. Here, it helps to have an assistant or another family member to help. Patience and a good sense of humor help, too.

lighting ideas

One thing that works in favor of a successful photo is to have the lighting all ready to go before the pet arrives. I usually opt for a very simple lighting setup so I don't have to mess with the lights when the pet is on the set. In the studio, the key light can be either a softbox or a harder light source, depending on what you want to accomplish, the color of the fur, and how well the animal can follow directions. Fur texture is important. A rim light can help highlight the pet's fur when focusing on just the animal.

Pets don't do well with loud noises or surprises, so if I use a flexible bounce disc, I open it in another room or prior to the session so I don't disrupt the animal. If strobes make a pop when fired, they may be quieter at a lower setting.

If working outdoors, we plan the photo session for late afternoon, especially with sunlight, to allow for backlight to come through the fur.

But beyond basic lighting, it is always the personality that makes the portrait.

Facing page: This image was shot for Getty Images as part of a series of "Old Master" animal portraits (others include the Great Dane on page 101, a turtle, and a rabbit). This girl, age six, came with her own dog. We brought in four greyhounds at the end of the session. She was completely relaxed and got along well, especially with this dog named Dash.

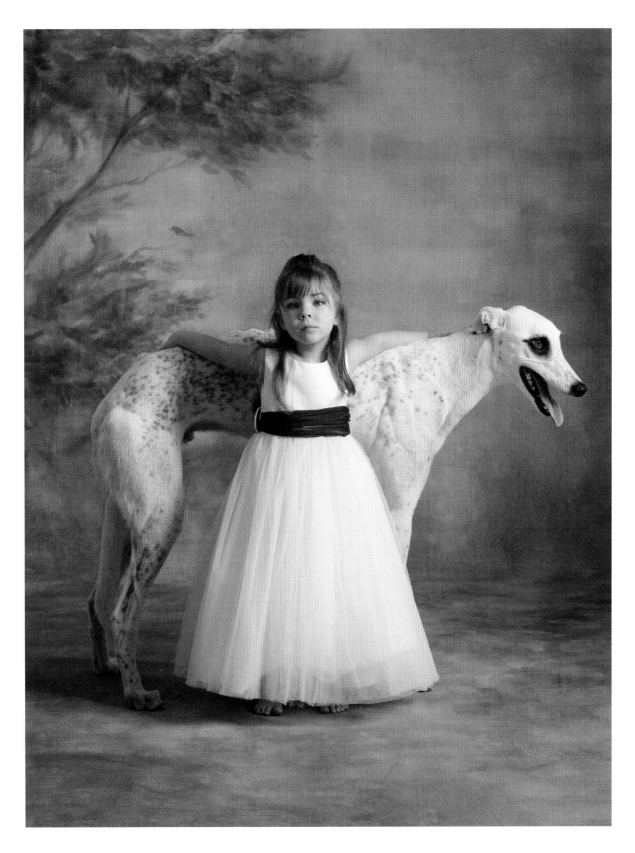

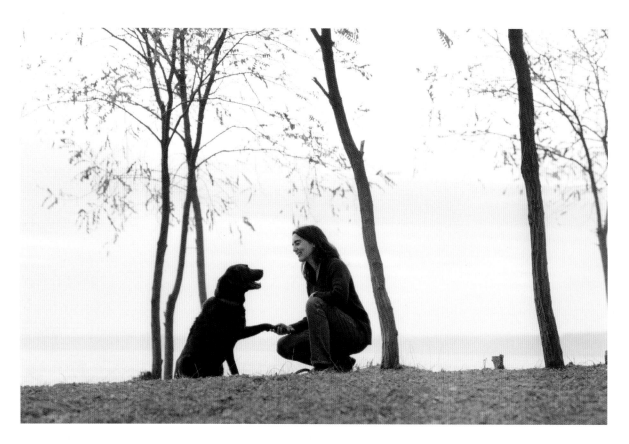

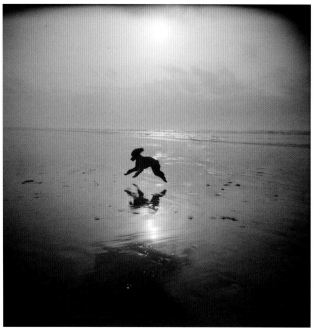

Above: I photographed from a low angle to take advantage of the sky and water in the background, outlining a calligraphic silhouette of the trees and the body language of the woman and her dog. Left: The joyful dog was photographed racing on the beach in Oregon. The image was shot with a Holga camera. Facing page: Another of the series of Old Master animal portraits using a painted backdrop and a softbox for lighting.

Pages 102 and 103: A girl and her dog in a priceless Old Master moment, a curly-haired girl and her smiling dog, and two of my favorite cats.

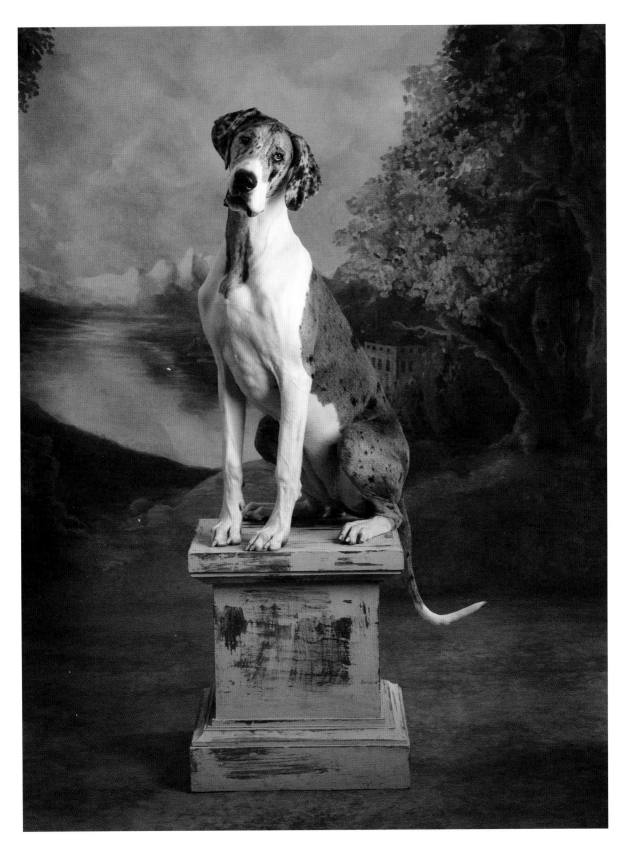

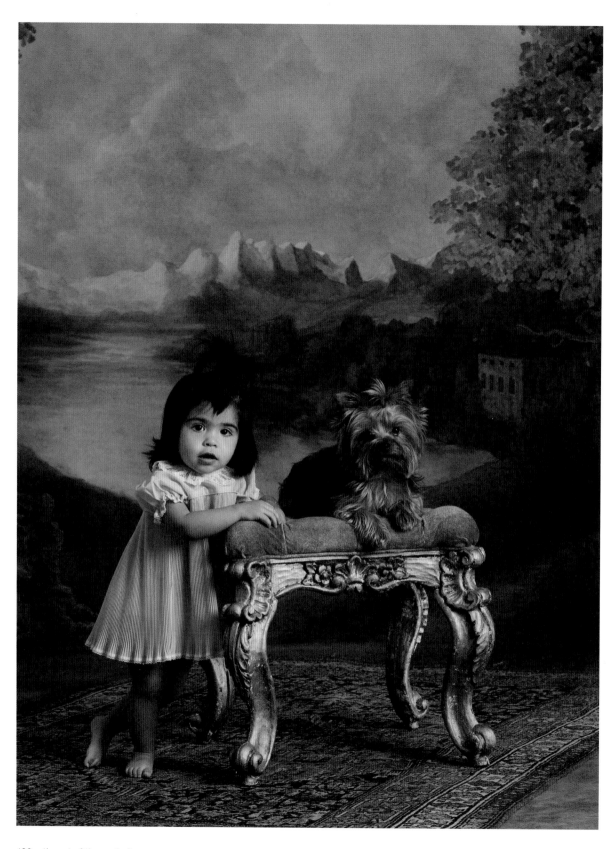

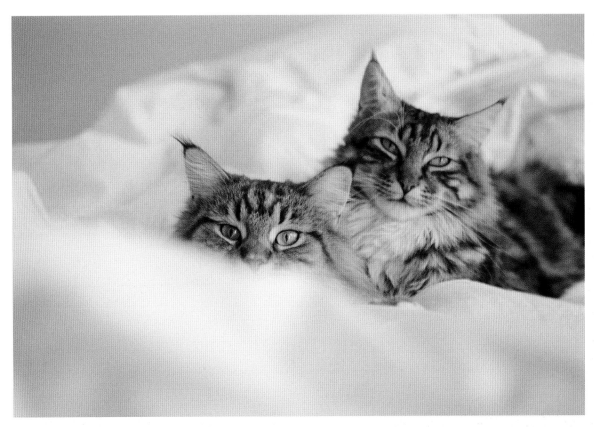

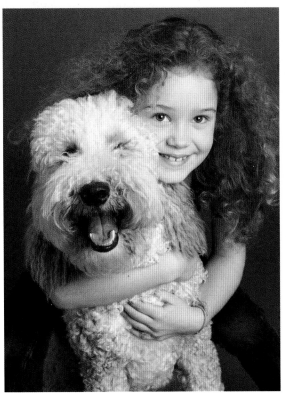

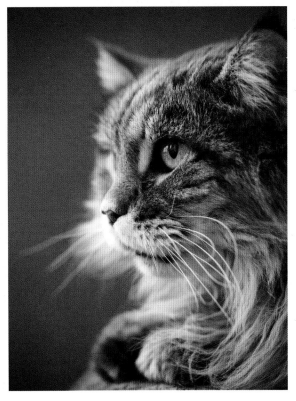

17 fine art portraits

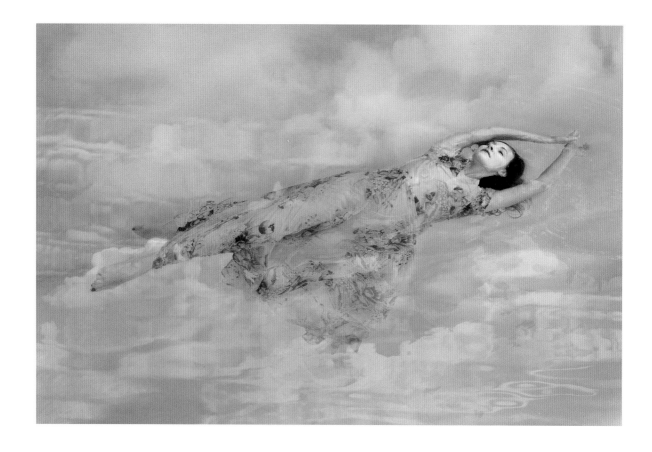

Sometimes I make photos just to explore my own inner world. The people I photograph are my collaborators, which is often the case in portraiture. But in the case of fine art, the result may be not a portrait of the actual person but rather the development of an idea that may have less to do with the individual and more to do with a concept—or the inner life of the creator.

The images in this chapter belong to bodies of work that I've exhibited at galleries. The titles of the collections include *Rapture* (pages 104 and 105), *Four & 20 Blackbirds,* and *Animal Dreams* (pages 106–109), among others.

These explorations are akin to dissecting the world of dreams or fairytales. I create a bit of a story and then go about finding the props,

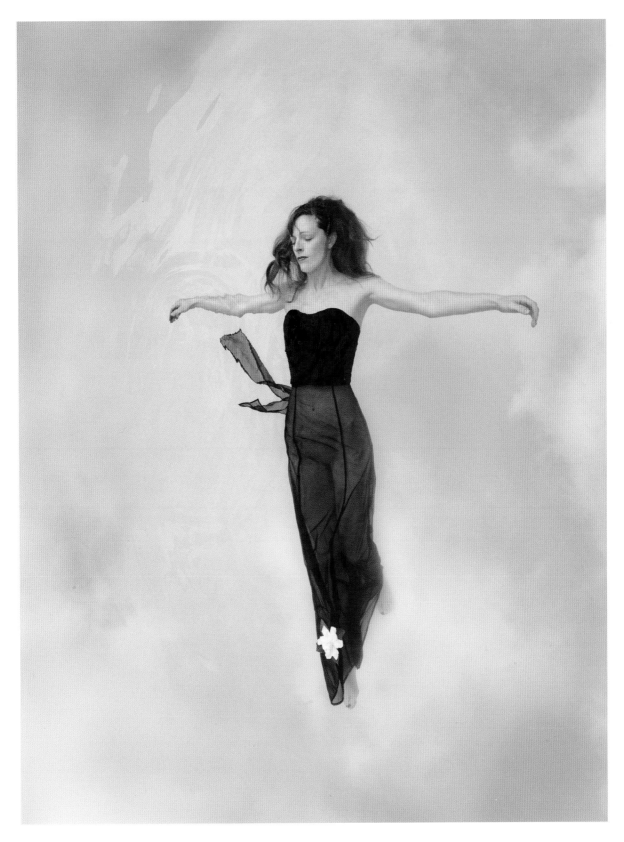

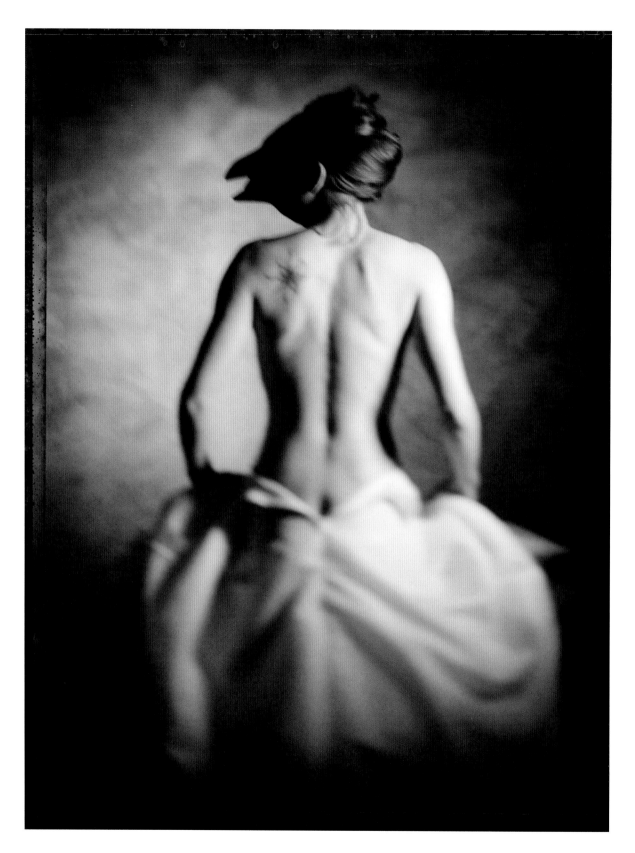

dresses, masks, and locations that will suit my vision. Sometimes I sketch out my ideas. Sometimes I just gather the props and the model and see what happens when I put it all together.

I happen to have a fascination with blackbirds and ravens, so they appear often in my images, representing a bit of magic for me.

The conception of the series called *Animal Dreams* came about when I discovered some haunting antique papier maché circus masks owned by a local collector. The masks interested me because of a dream I had when I was a child in which the animals printed on my bedroom linoleum came to life in the middle of the night. It was somewhat like a scene from *The Twilight Zone,* but for me, as an artist, it was exciting to pursue the idea through images.

The *Rapture* series is my personal exploration of what happens to us after we die–imagining us at that place in-between, perhaps floating in the clouds. It is a look at transition that also draws upon a lifetime of dreams of floating in the air.

I always encourage my students to take on personal work. It helps explore personal style, which translates to all of one's creative work, whether photography or another means of expression.

One thing that has helped me greatly over the years is participating in creative groups. I belong to a creative group called Art Chix, which has been meeting monthly for many years. Each month we meet and give ourselves an assignment, such as the word "swimmer," and then go away to create a piece of art that we will show at our next meeting.

This group has been partly responsible for and very inspirational in almost all of the collections I have done, including my work about women and body image, and the other images on the pages of this chapter. The group provides feedback and support.

For people who don't have a creative group, it is not difficult to start one. And the rewards are huge.

Creative groups can stimulate us and inspire us to explore possibilities.

How to get one's work seen is another question. I recommend entering contests, participating in group and solo exhibits, going to others' exhibits, using social media, and networking. Photography can be very much a solo practice. It's a good thing to get the work seen by your friends, neighbors, and around the world.

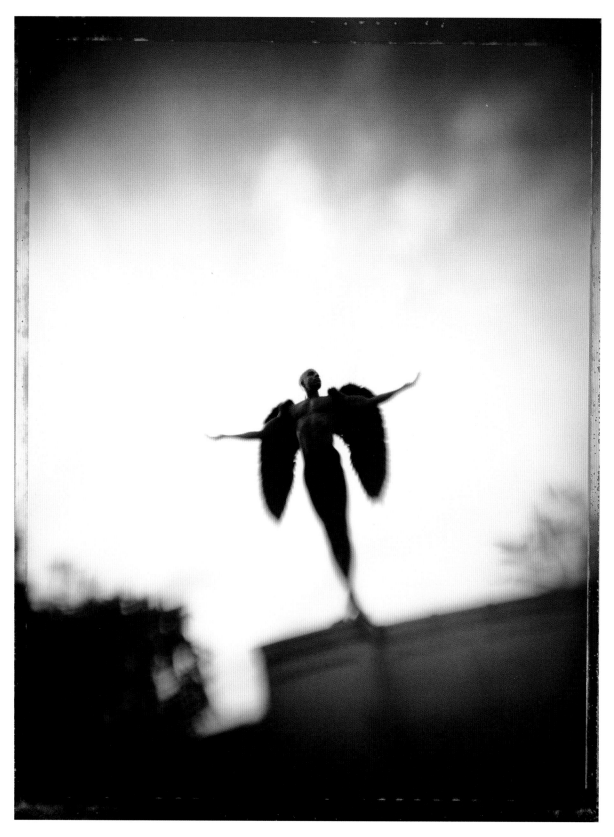

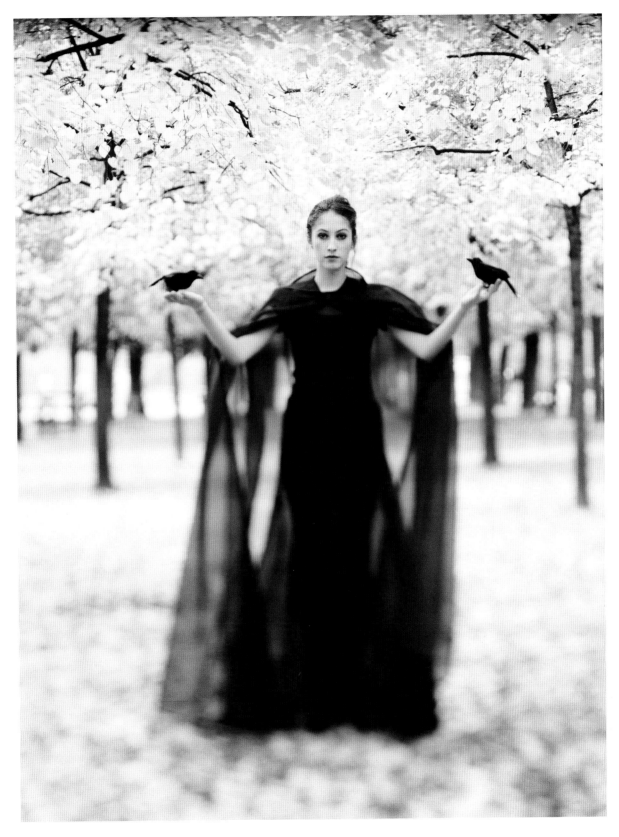

18 the business of photography

Learning photography as an avocation is complicated. One has to learn about equipment, lighting, composition, and working with people, as well as how to process images, control color, and make good prints. On and on it goes. But then comes the question of what to do with the photography that we love so much.

We can give our photos to friends and family, frame them, exhibit them at coffee shops, and make personal books. That's all wonderful. But for those who decide to pursue a professional route, what is the first step? Or the next step?

the many ways to become a pro

There are many ways to be a professional photographer, several of which are addressed in this book. For example, photojournalism, editorial photography, portrait photography, commercial (advertising/corporate) photography, event photography, public relations, stock, fine art, and more.

The first step is to examine the kind of work you love, which can mean more than one type of photography at a time. For example, it is possible to do editorial photography and commercial photography at the same time. Or portrait photography and commercial photography. What many non-professional photographers don't know (yet) is that different fields of photography have different business models, which may seem a bit daunting.

the basics for any professional

In all cases in professional photography, the photographer is expected to be highly technically skilled and highly professional in dealing with clients and subjects. To be in business, one needs a business license, an accounting system, and some kind of marketing plan. Professional photographers should carry business insurance (liability and equipment) and have a polished website of their work, model and property releases, and so on.

editorial photography

The field of editorial photography (for magazines or newspapers) can cover portraiture, food, fashion, beauty, travel, and more. Photographers usually work for a specified day rate,

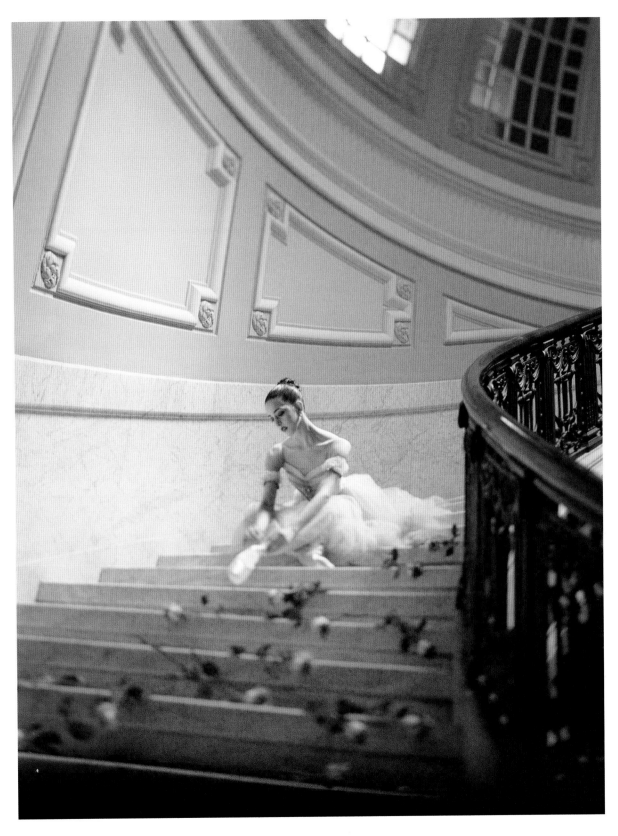

which is the fee they are paid outside of expenses. For most editorial work, the fee is not nearly as high as the fee paid in advertising, however, and the photographer will normally get a photo credit, which can lead to more work.

The publication hiring the photographer will often advance the projected expenses to the photographer (such as travel, food, stylist, assistant, and equipment rental). The remainder will be paid upon receipt of the images. There may be further payment if more images are used than initially specified and/or if the photo is used as a cover image. The photographer will likely be asked to submit an estimate to the photo editor or art director after discussing which approach to use to make the photographs. Normally the photographer retains the rights to the images after the publication has run the article, but this is a matter that one should pay close attention to, as some publications request ownership of any images they use.

commercial photography

Commercial photography includes advertising and annual report photography. Photo specialties include portraiture, food, fashion, beauty, automobiles, and more. Commercial photography is similar to editorial photography in that the photographer is paid a creative fee, plus expenses. There may be an additional fee for additional usage. For example, if the ad runs in print (e.g., magazines) for a certain number of insertions or certain length of time, there might be one negotiated fee, but if the ad is also used on the Internet, there may be another fee. This should all be negotiated in advance of the project. Commercial work is very competitive. Many commercial/advertising photographers work with representatives who help with the marketing and negotiations. The quality of work must be very high, as there is a lot of client money involved in the outcome of the products. Thus, the pay scale is higher than editorial.

wedding and portrait photography

Another field of photography is that of wedding and portrait photography. Portraiture can be broken down into sub-specialties such as children's portraiture, high school senior portraits, glamour or boudoir, sports, business portraits, and more. Some photographers do both wedding and portrait photography. The business models for wedding and portrait photography differ from those of commercial and editorial work. Often there is a session fee for the photography, and then the photographer depends on print sales to earn a living. Conferences such as PDN Photo Plus in New York, WPPI in Las Vegas, and Imaging USA (PPA) offer educational workshops for photographers, as do other professional organizations.

fine art photography

Fine art photography in galleries is another segment of the business of photography. It is equally, if not more, competitive than the other fields. Fine art sales depend on establishing a relationship with a gallery. It requires understanding and keeping careful track of print editions and pricing, in addition to creating work that is unique and desirable (not always a predictable quality). It also demands developing relationships, networking, and going to fine art portfolio review events such as FotoFest (fotofest.org) in Houston, PhotoLucida (photolucida.org) in Portland, Oregon, Paris Photo (parisphoto.com), and others in the U.S. and around the world.

It is not always obvious how the various business models work, nor how much one should charge for professional photography. One way to go about discovering the answers for yourself is to develop friendships with other photographers in similar fields. Many photographers begin their careers by assisting established photographers. Networking, volunteering, and friendship are the keys to moving forward. In addition, there are several national professional organizations whose goal it is to help photographers learn about the business of photography and how to succeed.

These organizations have local organizations in metropolitan areas around the country. They provide great opportunities to learn and network.

professional organizations

- ASMP (American Society of Media Photographers)—asmp.org
- APA (American Photographic Artists) — apanational.org
- PPA (Professional Photographers of America)—ppa.com
- WPPI (Wedding and Portrait Photographers International)—wppionline.com
- SPE (Society of Professional Educators)— spenational.org

other resources

- *Photo District News* magazine (among others)
- CreativeLive classes (creativelive.com)
- Advice and books by Mary Virginia Swanson (mvswanson.com/advice-books/books-by-mvs)
- *The Professional Photographer's Legal Handbook (Allworth Press 2007)* by Nancy E. Wolff
- *The Artist's Guide to Grant Writing (Watson-Guptill 2010)* by Gigi Rosenberg

19 a peek behind the scenes

I assume that every photographer wonders how other photographers do their work. I know I did when I first started out. There are so many things to learn, even after many years of working. Just learning about lighting is huge. There is natural light, available to all of us, and artificial sources, including continuous lights, dedicated flash (speedlights), and strobes. When we see the work of a photographer, it often has a look that is a reflection of the studio or environment in which the photographer works.

I teach lighting, so naturally I think it is important that photographers have an understanding of lighting. It's not only important—it's imperative! When lighting skills are in place, the photographer can work confidently with the subject without stumbling over f/stops, shutter speeds, and other technical details of managing light. And whether the rain is pouring down or the noon sun is just too harsh, learning to use light well helps make a beautiful image regardless of what nature throws our way.

But even without all of those skills in place, at least at first, a photographer can do wonders just working from the heart and a connection.

When I first started doing photography I knew nothing about working with photographic lighting, so all my images were lit with natural light. But I did know about connection, composition, and storytelling. I later discovered the magic of lighting while working in my newspaper job. The point at which I realized, to my dismay, that not every photo could be lit with natural light was an eye-opening assignment. I was assigned to do a story about . . . *liver.*

I then decided to seek advice about working with studio strobes. I talked to a food photographer who told me to keep my light angle low. I read all of the books I could find. I experimented with the ancient strobes in the newspaper's studio and I attended workshops. Eventually, working with strobes became a tool I could use with the same confidence that a chef has when preparing a meal.

Let's look at some ideas and simple tools that may be of use.

Facing page: Late-afternoon sun filtered through the model's hair and the long grass. The fill on her face was from a white fill card.

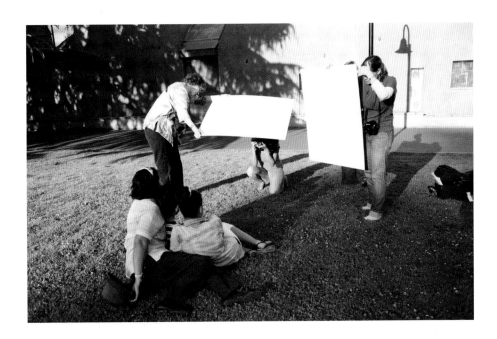

working on a budget

As I mentioned, one doesn't need to have a big studio to do portraits—or even a small studio. What is useful, however, is to have a room with a large window that faces north. North light allows for soft, even light throughout the day (in the Northern hemisphere) with a directional quality, much like that produced by a softbox.

The room's walls should be white or neutral in color, but there are ways around this. For example, one can purchase 4x8-foot sheets of foam core at an art store to use as a background or set up a simple white paper seamless or a painted backdrop. Then, besides the camera, a piece of 30x40-inch foam core mounted on a light stand will allow for control of the shadows and the amount of drama in the portrait.

That same piece of foam core, mounted on a light stand or held by an assistant, will work indoors or outdoors to bounce back light onto the subject's face. This is an art that takes some time to refine for a gentle, rounded fill.

Facing page: The portraits, taken by a north-facing window with a fill card, depict how such a simple tool can change the quality of light. The photo on the lower left is unfilled. The one on the right is filled. The distance of the card from the face can dramatically change the shadow side of the image from dark to light.

Above: A group of students work with back light and fill cards. The card above the photographer is used as a "flag" to prevent flare. For more information about light, see ABCs of Beautiful Light.

professional shoots

When working for clients, it is imperative to be as organized as possible. I have a checklist for equipment, plus a way of packing my equipment, when going on location, that is consistent so I know if something is missing. For example, my strobes are packed in a certain way in my light cases, with the cords coiled just so. Then in go the PocketWizards (wireless transmitters), extra batteries, an extra sync cord, etc. I can tell at a glance if anything is missing.

I take two camera bodies, extra flash (media) cards, sometimes my laptop, model releases, and phone numbers. Depending on the size of the shoot, we may have models, makeup artists, wardrobe stylists, assistants, an art director, a producer, the client, etc. Everyone needs to be fed, so we will cater food for breakfast/lunch/dinner, depending on the timing and duration of the shoot. If a shoot is on location, we will hire an RV so clothing can be steamed, makeup applied, clothing changed, and food served.

producing the shoot

Every shoot requires forethought and planning. If photographing in the studio, I will have the backdrop ready and the strobes set up and metered as a starting point. If photographing in a home or other location, I will often look at the site beforehand so I can plan for the situation.

I would say that more often than not, the scenario is never as one might think and in most cases, it is worse! So a bit of advance mental preparation and planning will work wonders. It is important to keep in mind that the photographs we create can outlast us. They might be passed on for generations. Thus, it is important to get it right—even if it requires moving furniture or suggesting alternate locations or wardrobe changes.

On larger shoots, the planning can take weeks, involving endless details, discussions, sketching of ideas, organizing crew, renting equipment, and more. With larger shoots, photographers often work with producers who specialize in working out the details in advance, leaving the photographer free to do what he or she does best: make photographs.

Facing page: For this photo, taken in the El Yunque rainforest in Puerto Rico, there was a lot of advanced planning. The location had to be scouted, which meant driving hundreds of miles in all directions. Then a model casting session was held. The two models–sisters–had to be outfitted. On the day of the shoot, an RV took the crew to the site where we set up the lights, under plastic sheeting and umbrellas, testing them while a setdresser added orchids here and there. The models waited in the RV for their moment as the rainforest continued to rain. Finally, the skies cleared long enough for us to get the shot.

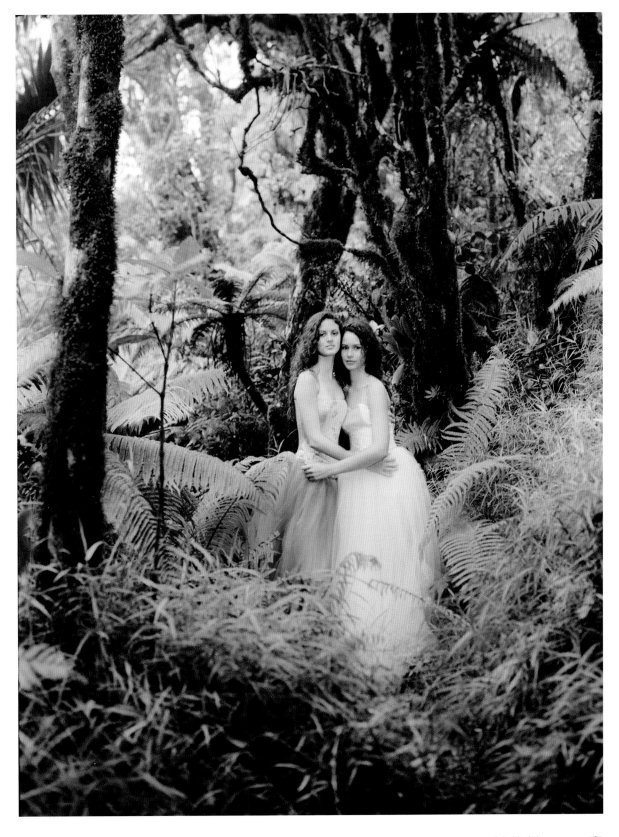

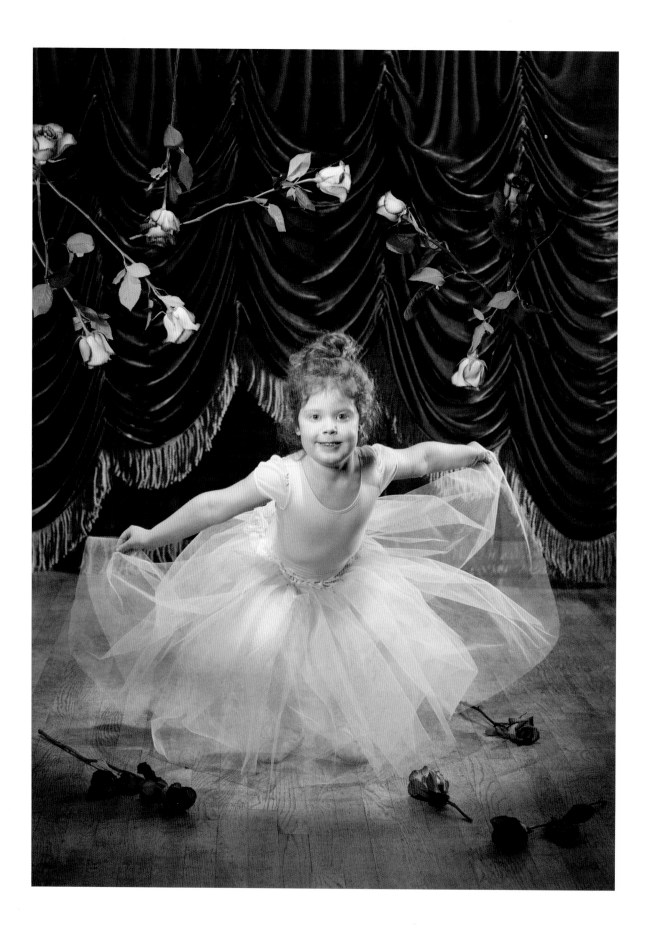

little ballerina

This image was created for a card company. The art director wanted a photo of a little ballerina in an awkward curtsey as roses rained down on her. Every little girl's dream.

The floor needed to be scuffed hardwood, and the location needed high ceilings for lighting. A theater curtain was made for the set and shipped to me for the photo shoot. The dress had to be pink with a pink sash and the shoes were to be pink. The lighting had to seem like a stage spotlight. All of this was accomplished long distance with sketches, e-mails, and phone conversations.

We did several casting calls for just the right child and selected two, just in case. The two girls were different sizes, so the clothing and shoes had to be doubled. The idea of "tossing" roses onto a set was unpredictable at best and somewhat dangerous with the thorns and stems, so they were strung up with clear fishing line (we also took photos without the roses).

The location ended up being an old school room with hardwood floors. The lighting setup (shown above) involved numerous lights. The girls, aged 4 and 5, were shy at first, but soon enough they got the hang of it, and it turned out to be fun for everyone.

We were all happy with the outcome. However, in the end, the card company decided to go a different direction, so the image wasn't used.

location scouting

Whether doing a senior portrait, a family portrait, or an individual portrait for a magazine or advertisement, finding the right location is important. If working on a small scale, I will scout my own locations. I try to arrive at the time of day best for the shoot so I can see what the light will be like for the actual photo session. I always take my camera (it could be a cell phone, but it's better with the real thing), and it is very useful to have someone stand in for the subject. The goal is to find a location that allows for a sense of background that adds to the story rather than one that detracts or draws attention away from the subject.

The goal is to find a location that allows for a sense of background that adds to the story.

When I am working on a large job, especially in another city, I rely on location scouts who understand photography to search out the right locations. They will organize a collection of images that indicate direction of light. Be aware that some locations will require advance planning and permitting. If working on an individual portrait, one can usually find a park or other location that does not involve obtaining permits, but for an editorial or advertising job, a permit might be required. It

is good to inquire about city or park permits before bringing a crew to a site that requires one.

A little story: The producer I worked with on the job for the New York City Ballet made sure permits were in place prior to the shoot. This is especially important in advertising. For this particular shoot, the weather was overcast and cool for two days, which was workable. But on the third day the heavens broke loose. It rained so hard that the drops bounced knee-high from the pavement. That day we were scheduled to photograph at Riverside Park on the west side of Manhattan. But there was no way we could get the ballerinas outdoors in their frothy, costly dresses. Right next to us was the elegant Grant's Tomb with a giant portico that offered protection from the rain. But . . . could we shoot there? The wonderful producer, who had planned for every possible detail, had gotten a permit just in case—so the shoot went on. You can see one of those rainy-day images on page 71.

equipment

One does not need a lot of equipment to make beautiful photographs. But as I tell my students, better is usually better. A camera with a full-frame sensor is good. A couple of good lenses are important. My preference, if I had only one lens, would be a 24–70mm f/2.8. The

wide aperture is better for portraiture than lenses with variable apertures that change with the focal length, making it difficult to achieve a shallow depth of field. My other favorite is an 85mm f/1.2.

But even so, portraits are really a result of connection with the subject and the quality of light. Memorable portraits can be created with anything from a camera with a plastic lens (such as a Holga) to large-format cameras with high-quality lenses.

I generally don't work with a tripod when doing portraits with my SLR because I like to move a lot when working—get high, get low, move left, move right. The tripod limits my movement. So rather than work with a slow shutter speed, I will raise the ISO so I can keep the blur out of the image (unless I am trying to achieve blur on purpose). Cameras vary in their ability to handle high ISOs, so it is best to experiment to avoid having too much digital noise.

getting experience

Becoming good at portraiture or cooking or speaking a new language is, of course, a matter of practice. I recommend studying the masters, such as Irving Penn, Richard Avedon, Arnold Newman, Annie Liebovitz, Diane Arbus, Herb Ritts, Gregory Heisler, and Brian Lanker, to name a few. Collect tear sheets (that is, samples from books or magazines) by photographing them with your phone. Study body language, eye contact, wardrobe, light, and locations. Then take on a project of making photographs of something or someone that has meaning to you.

Many photographers who are just starting out are more nervous than their subjects. Build in time for conversation. When the subject is at ease, the photographer can be more at ease. Then the whole session is more relaxed and the outcome is more successful.

Of course, this comes with time, but it won't happen without practice and more practice. Along the way of learning about photographing others, we learn about ourselves.

Good portraits to you!

Rosanne Olson

index

Mastering Light

Curley Marshall presents some of his favorite images and explores the classic lighting approaches he used to make them more expressive. *$34.95 list, 7x10, 128p, 180 color images, index, order no. 2088.*

Sikh Weddings

Gurm Sohal is your expert guide to photographing this growing sector of the wedding market. With these skills, you'll shoot with confidence! *$34.95 list, 7x10, 128p, 180 color images, index, order no. 2093.*

Senior Style

Tim Schooler is well-known for his fashion-forward senior portraits. In this book, he walks you through his approach to lighting, posing, and more. *$34.95 list, 7.5x10, 128p, 220 color images, index, order no. 2089.*

Profit-Building for Pro Photographers

Jeff and Carolle Dachowski teach you marketing, pricing, sales, and branding— the keys to a successful business. *$34.95 list, 7x10, 128p, 180 color images, index, order no. 2094.*

The Complete Guide to Bird Photography

Jeffrey Rich shows you how to choose gear, get close, and capture the perfect moment. A must for bird lovers! *$29.95 list, 7x10, 128p, 294 color images, index, order no. 2090.*

Master Low Light Photography

Heather Hummel takes a dusk-to-dawn tour of photo techniques and shows how to make natural scenes come to life. *$34.95 list, 7x10, 128p, 180 color images, index, order no. 2095.*

Relationship Portraits

Tim Walden shows you how he infuses his black & white portraits with narrative and emotion, for breath-taking results that will stand the test of time. *$34.95 list, 7x10, 128p, 180 color images, index, order no. 2091.*

Wedding Photography Kickstart

Pete and Liliana Wright help you shift your wedding photo business into high gear and achieve unlimited success! *$34.95 list, 7x10, 128p, 180 color images, index, order no. 2096.*

Smart Phone Microstock

Mark Chen walks you through the process of making money with images from your cell phone—from shooting marketable work to getting started selling. *$34.95 list, 7x10, 128p, 180 color images, index, order no. 2092.*

101 Mistakes Photographers Should Never Make

Karen Dórame solves some of the problems that can result in poor images and failing photography businesses. *$34.95 list, 7x10, 128p, 340 color images, index, order no. 2097.*

JUN -- 2016
3492204